TOWARDS A PHILOSOPHY OF PHOTOGRAPHY

Towards a Philosophy of Photography

Vilém Flusser

REAKTION BOOKS

Published by Reaktion Books Ltd
33 Great Sutton Street, London EC1V 0DX, UK

www.reaktionbooks.co.uk

Originally published in German as *Für eine Philosophie der Fotografie*

Copyright © 1983 EUROPEAN PHOTOGRAPHY Andreas Müller-Pohle,
P.O. Box 3043, D-37020 Göttingen, Germany, www.equivalence.com
EDITION FLUSSER, Volume III (2000)

English-language translation copyright © Reaktion Books 2000
Reprinted 2005, 2006, 2007, 2009, 2010, 2012, 2014

Afterword copyright © Hubertus von Amelunxen 2000

Translated by Anthony Mathews

Cover designed by Philip Lewis
Text designed by Ron Costley

Printed and bound in Great Britain
by Bell & Bain, Glasgow

British Library Cataloguing in Publication Data:

Flusser, Vilém, 1920–1991
 Towards a philosophy of photography
 Photography – Philosophy
 I. Title
 770.1

ISBN: 978 1 86189 076 4

Contents

Introductory Note

This book is based on the hypothesis that two fundamental turning points can be observed in human culture since its inception. The first, around the middle of the second millennium BC, can be summed up under the heading 'the invention of linear writing'; the second, the one we are currently experiencing, could be called 'the invention of technical images'. Similar turning points may have occurred previously but are beyond the scope of this analysis.

This hypothesis contains the suspicion that the structure of culture – and therefore existence itself – is undergoing a fundamental change. This book attempts to strengthen this suspicion and, in order to maintain its hypothetical quality, avoids quotations from earlier works on similar themes. For the same reason, there is no bibliography. However, there is a short glossary of the terms employed and implied in the course of the discussion; these definitions are not intended to have general validity but are offered as working hypotheses for those who wish to follow up the concepts arising from the thoughts and analyses presented here.

Thus the intention of this book is not to defend a thesis but to make a contribution – informed by philosophy – to the debate on the subject of 'photography'.

The Image

Images are significant surfaces. Images signify – mainly – something 'out there' in space and time that they have to make comprehensible to us as abstractions (as reductions of the four dimensions of space and time to the two surface dimensions). This specific ability to abstract surfaces out of space and time and to project them back into space and time is what is known as 'imagination'. It is the precondition for the production and decoding of images. In other words: the ability to encode phenomena into two-dimensional symbols and to read these symbols.

The significance of images is on the surface. One can take them in at a single glance yet this remains superficial. If one wishes to deepen the significance, i.e. to reconstruct the abstracted dimensions, one has to allow one's gaze to wander over the surface feeling the way as one goes. This wandering over the surface of the image is called 'scanning'. In so doing, one's gaze follows a complex path formed, on the one hand, by the structure of the image and, on the other, by the observer's intentions. The significance of the image as revealed in the process of scanning therefore represents a synthesis of two intentions: one manifested in the image and the other belonging to the observer. It follows that images are not 'denotative' (unambiguous) complexes of symbols (like numbers, for example) but 'connotative' (ambiguous) complexes of symbols: They provide space for interpretation.

While wandering over the surface of the image, one's gaze takes in one element after another and produces tem-

poral relationships between them. It can return to an element of the image it has already seen, and 'before' can become 'after': The time reconstructed by scanning is an eternal recurrence of the same process. Simultaneously, however, one's gaze also produces significant relationships between elements of the image. It can return again and again to a specific element of the image and elevate it to the level of a carrier of the image's significance. Then complexes of significance arise in which one element bestows significance on another and from which the carrier derives its own significance: The space reconstructed by scanning is the space of mutual significance.

This space and time peculiar to the image is none other than the world of magic, a world in which everything is repeated and in which everything participates in a significant context. Such a world is structurally different from that of the linear world of history in which nothing is repeated and in which everything has causes and will have consequences. For example: In the historical world, sunrise is the cause of the cock's crowing; in the magical one, sunrise signifies crowing and crowing signifies sunrise. The significance of images is magical.

The magical nature of images must be taken into account when decoding them. Thus it is wrong to look for 'frozen events' in images. Rather they replace events by states of things and translate them into scenes. The magical power of images lies in their superficial nature, and the dialectic inherent in them – the contradiction peculiar to them – must be seen in the light of this magic.

Images are mediations between the world and human beings. Human beings 'ex-ist', i.e. the world is not immediately accessible to them and therefore images are needed to make it comprehensible. However, as soon as this

happens, images come between the world and human beings. They are supposed to be maps but they turn into screens: Instead of representing the world, they obscure it until human beings' lives finally become a function of the images they create. Human beings cease to decode the images and instead project them, still encoded, into the world 'out there', which meanwhile itself becomes like an image – a context of scenes, of states of things. This reversal of the function of the image can be called 'idolatry'; we can observe the process at work in the present day: The technical images currently all around us are in the process of magically restructuring our 'reality' and turning it into a 'global image scenario'. Essentially this is a question of 'amnesia'. Human beings forget they created the images in order to orientate themselves in the world. Since they are no longer able to decode them, their lives become a function of their own images: Imagination has turned into hallucination.

This appears to have happened once before, in the course of the second millennium BC at the latest, when the alienation of human beings from their images reached critical proportions. For this very reason, some people tried to remember the original intention behind the images. They attempted to tear down the screens showing the image in order to clear a path into the world behind it. Their method was to tear the elements of the image (pixels) from the surface and arrange them into lines: They invented linear writing. They thus transcoded the circular time of magic into the linear time of history. This was the beginning of 'historical consciousness' and 'history' in the narrower sense. From then on, historical consciousness was ranged against magical consciousness – a struggle that is still evident in the stand taken against images by the

Jewish prophets and the Greek philosophers (particularly Plato).

The struggle of writing against the image – historical consciousness against magic – runs throughout history. With writing, a new ability was born called 'conceptual thinking' which consisted of abstracting lines from surfaces, i.e. producing and decoding them. Conceptual thought is more abstract than imaginative thought as all dimensions are abstracted from phenomena – with the exception of straight lines. Thus with the invention of writing, human beings took one step further back from the world. Texts do not signify the world; they signify the images they tear up. Hence, to decode texts means to discover the images signified by them. The intention of texts is to explain images, while that of concepts is to make ideas comprehensible. In this way, texts are a metacode of images.

This raises the question of the relationship between texts and images – a crucial question for history. In the medieval period, there appears to have been a struggle on the part of Christianity, faithful to the text, against idolaters or pagans; in modern times, a struggle on the part of textual science against image-bound ideologies. The struggle is a dialectical one. To the extent that Christianity struggled against paganism, it absorbed images and itself became pagan; to the extent that science struggled against ideologies, it absorbed ideas and itself became ideological. The explanation for this is as follows: Texts admittedly explain images in order to explain them away, but images also illustrate texts in order to make them comprehensible. Conceptual thinking admittedly analyzes magical thought in order to clear it out of the way, but magical thought creeps into conceptual thought so as to bestow

significance on it. In the course of this dialectical process, conceptual and imaginative thought mutually reinforce one another. In other words, images become more and more conceptual, texts more and more imaginative. Nowadays, the greatest conceptual abstraction is to be found in conceptual images (in computer images, for example); the greatest imagination is to be found in scientific texts. Thus, behind one's back, the hierarchy of codes is overturned. Texts, originally a metacode of images, can themselves have images as a metacode.

That is not all, however. Writing itself is a mediation – just like images – and is subject to the same internal dialectic. In this way, it is not only externally in conflict with images but is also torn apart by an internal conflict. If it is the intention of writing to mediate between human beings and their images, it can also obscure images instead of representing them and insinuate itself between human beings and their images. If this happens, human beings become unable to decode their texts and reconstruct the images signified in them. If the texts, however, become incomprehensible as images, human beings' lives become a function of their texts. There arises a state of 'textolatry' that is no less hallucinatory than idolatry. Examples of textolatry, of 'faithfulness to the text', are Christianity and Marxism. Texts are then projected into the world out there, and the world is experienced, known and evaluated as a function of these texts. A particularly impressive example of the incomprehensible nature of texts is provided nowadays by scientific discourse. Any ideas we may have of the scientific universe (signified by these texts) are unsound: If we do form ideas about scientific discourse, we have decoded it 'wrongly'; anyone who tries to imagine anything, for example, using the equation of the theory of

relativity, has not understood it. But as, in the end, all concepts signify ideas, the scientific, incomprehensible universe is an 'empty' universe.

Textolatry reached a critical level in the nineteenth century. To be exact, with it history came to an end. History, in the precise meaning of the word, is a progressive transcoding of images into concepts, a progressive elucidation of ideas, a progressive disenchantment (taking the magic out of things), a progressive process of comprehension. If texts become incomprehensible, however, there is nothing left to explain, and history has come to an end.

During this crisis of texts, technical images were invented: in order to make texts comprehensible again, to put them under a magic spell – to overcome the crisis of history.

The Technical Image

The technical image is an image produced by apparatuses.
As apparatuses themselves are the products of applied
scientific texts, in the case of technical images one is deal-
ing with the indirect products of scientific texts. This gives
them, historically and ontologically, a position that is dif-
ferent from that of traditional images. Historically, tradi-
tional images precede texts by millennia and technical
ones follow on after very advanced texts. Ontologically,
traditional images are abstractions of the first order
insofar as they abstract from the concrete world while
technical images are abstractions of the third order: They
abstract from texts which abstract from traditional images
which themselves abstract from the concrete world.
Historically, traditional images are prehistoric and tech-
nical ones 'post-historic' (in the sense of the previous
essay). Ontologically, traditional images signify pheno-
mena whereas technical images signify concepts. Decoding
technical images consequently means to read off their
actual status from them.

Technical images are difficult to decode, for a strange
reason. To all appearances, they do not have to be decoded
since their significance is automatically reflected on their
surface – just like fingerprints, where the significance (the
finger) is the cause and the image (the copy) is the conse-
quence. The world apparently signified in the case of tech-
nical images appears to be their cause and they themselves
are a final link in a causal chain that connects them with-
out interruption to their significance: The world reflects

the sun's and other rays which are captured by means of optical, chemical and mechanical devices on sensitive surfaces and as a result produce technical images, i.e. they appear to be on the same level of reality as their significance. What one sees on them therefore do not appear to be symbols that one has to decode but symptoms of the world through which, even if indirectly, it is to be perceived.

This apparently non-symbolic, objective character of technical images leads whoever looks at them to see them not as images but as windows. Observers thus do not believe them as they do their own eyes. Consequently they do not criticize them as images, but as ways of looking at the world (to the extent that they criticize them at all). Their criticism is not an analysis of their production but an analysis of the world.

This lack of criticism of technical images is potentially dangerous at a time when technical images are in the process of displacing texts – dangerous for the reason that the 'objectivity' of technical images is an illusion. For they are – like all images – not only symbolic but represent even more abstract complexes of symbols than traditional images. They are metacodes of texts which, as is yet to be shown, signify texts, not the world out there. The imagination that produces them involves the ability to transcode concepts from texts into images; when we observe them, we see concepts – encoded in a new way – of the world out there.

With traditional images, by contrast, the symbolic character is clearly evident because, in their case, human beings (for example, painters) place themselves between the images and their significance. Painters work out the symbols of the image 'in their heads' so as to transfer them by means of the paintbrush to the surface. If one

wishes to decode such images, then one has to decode the encoding that took place 'in the head' of the painter.

With technical images, however, the matter is not so clearly evident. It is true that with these images another factor places itself between them and their significance, i.e. a camera and a human being operating it (for example, a photographer), but it does not look as if this 'machine/operator' complex would break the chain between image and significance. On the contrary: The significance appears to flow into the complex on the one side (input) in order to flow out on the other side (output), during which the process – what is going on within the complex – remains concealed: a 'black box' in fact. The encoding of technical images, however, is what is going on in the interior of this black box and consequently any criticism of technical images must be aimed at an elucidation of its inner workings. As long as there is no way of engaging in such criticism of technical images, we shall remain illiterate.

But there is something we can say about these images after all. For example, they are not windows but images, i.e. surfaces that translate everything into states of things; like all images, they have a magical effect; and they entice those receiving them to project this undecoded magic onto the world out there. The magical fascination of technical images can be observed all over the place: The way in which they put a magic spell on life, the way in which we experience, know, evaluate and act as a function of these images. It is therefore important to enquire into what sort of magic we are dealing with here.

Obviously it can hardly be the same magic as that of traditional images: The fascination that flows out of the television or cinema screen is a different fascination from

the sort that we observe in cave paintings or the frescoes of Etruscan tombs. Television and cinema are on a different level of existence from caves and the Etruscans. The ancient magic is prehistoric, it is older than historical consciousness; the new magic is 'post-historic', it follows on after historical consciousness. The new enchantment is not designed to alter the world out there but our concepts in relation to the world. It is magic of the second order: conjuring tricks with abstractions.

The difference between ancient and modern magic can be stated as follows: Prehistoric magic is a ritualization of models known as 'myths'; current magic is a ritualization of models known as 'programs'. Myths are models that are communicated orally and whose author – a 'god' – is beyond the communication process. Programs, on the other hand, are models that are communicated in writing and whose authors –'functionaries' – are within the communication process (the terms 'program' and 'functionary' will be explained later).

The function of technical images is to liberate their receivers by magic from the necessity of thinking conceptually, at the same time replacing historical consciousness with a second-order magical consciousness and replacing the ability to think conceptually with a second-order imagination. This is what we mean when we say that technical images displace texts.

Texts were invented in the second millennium BC in order to take the magic out of images, even if their inventor may not have been aware of this; the photograph, the first technical image, was invented in the nineteenth century in order to put texts back under a magic spell, even if its inventors may not have been aware of this. The invention of the photograph is a historical event as equally

decisive as the invention of writing. With writing, history in the narrower sense begins as a struggle against idolatry. With photography, 'post-history' begins as a struggle against textolatry.

For this was the situation in the nineteenth century: The invention of printing and the introduction of universal education resulted in everybody being able to read. There arose a universal consciousness of history that extended even to people in those strata of society who had previously lived a life of magic – the peasants – who now began to live a proletarian and historical life. This took place thanks to cheap texts: Books, newspapers, flyers, all kinds of texts became cheap and resulted in a historical consciousness that was equally cheap and a conceptual thinking that was equally cheap – leading to two diametrically opposed developments. On the one hand, traditional images finding refuge from the inflation of texts in ghettos, such as museums, salons and galleries, became hermetic (universally undecodable) and lost their influence on daily life. On the other hand, there came into being hermetic texts aimed at a specialist élite, i.e. a scientific literature with which the cheap kind of conceptual thinking was not competent to deal. Thus culture divided into three branches: that of the fine arts fed with traditional images which were, however, conceptually and technically enriched; that of science and technology fed with hermetic texts; and that of the broad strata of society fed with cheap texts. To prevent culture breaking up, technical images were invented – as a code that was to be valid for the whole of society.

Valid in the sense, in fact, that first, technical images were to introduce images back into daily life; second, they were to make hermetic texts comprehensible; and third,

they were to make visible the subliminal magic that was continuing to operate in cheap texts. They were to form the lowest common denominator for art, science and politics (in the sense of universal values), i.e. to be at one and the same time 'beautiful', 'true' and 'good', and in this way, as a universally valid code, they were to overcome the crisis of culture – of art, science and politics.

In fact, however, technical images function in a different way: They do not introduce traditional images back into life but, rather than replace them with reproductions, displace them and, rather than make hermetic texts comprehensible, as was intended, they distort them by translating scientific statements and equations into states of things, i.e. images. They do not make the prehistoric magic contained subliminally within cheap texts in any way evident but replace it with a new kind of magic, i.e. the programmed kind. For this reason, they cannot reduce culture, as was intended, to the lowest common denominator but, on the contrary, they grind it up into amorphous masses. Mass culture is the result.

The explanation for this is as follows: Technical images are surfaces that function in the same way as dams. Traditional images flow into them and become endlessly reproducible: They circulate within them (for example in the form of posters). Scientific texts flow into them and are transcoded from lines into states of things and assume magical properties (for example in the form of models that attempt to make Einstein's equation comprehensible). And cheap texts, a flood of newspaper articles, flyers, novels, etc. flow into them, and the magic and ideology inherent within them are translated into the programmed magic of technical images (for example in the form of photo-novels). Thus technical images absorb the whole of

history and form a collective memory going endlessly round in circles.

Nothing can resist the force of this current of technical images – there is no artistic, scientific or political activity which is not aimed at it, there is no everyday activity which does not aspire to be photographed, filmed, video-taped. For there is a general desire to be endlessly remembered and endlessly repeatable. All events are nowadays aimed at the television screen, the cinema screen, the photograph, in order to be translated into a state of things. In this way, however, every action simultaneously loses its historical character and turns into a magic ritual and an endlessly repeatable movement. The universe of technical images, emerging all around us, represents the fulfilment of the ages, in which action and agony go endlessly round in circles. Only from this apocalyptic perspective, it seems, does the problem of photography assume the importance it deserves.

The Apparatus

Technical images are produced by apparatuses. In saying this, one presumes that the typical characteristics of apparatuses as such – in a simplified, embryonic form – are also contained within the camera and can be derived from it. To this extent, the camera, as a prototype of the apparatuses that have become so decisive for the present and the immediate future, provides an appropriate starting point for a general analysis of apparatus – those apparatuses that, on the one hand, assume gigantic size, threatening to disappear from our field of vision (like the apparatus of management) and, on the other, shrivel up, becoming microscopic in size so as to totally escape our grasp (like the chips in electronic apparatuses). However, one must first attempt a more exact definition of the term 'apparatus', since various conceptions of it exist in current usage.

The Latin word *apparatus* is derived from the verb *apparare* meaning 'to prepare'. Alongside this there exists in Latin the verb *praeparare*, likewise meaning 'to prepare'. To illustrate in English the difference between the prefixes 'ad' and 'prae', one could perhaps translate *apparare* with 'pro-pare', using 'pro' in the sense of 'for'. Accordingly, an 'apparatus' would be a thing that lies in wait or in readiness for something, and a 'preparatus' would be a thing that waits patiently for something. The photographic apparatus lies in wait for photography; it sharpens its teeth in readiness. This readiness to spring into action on the part of apparatuses, their similarity to wild animals, is

something to grasp hold of in the attempt to define the term etymologically.

But etymology on its own is not sufficient to define a term. One has to enquire into the ontological status of apparatuses, their level of existence. They are indubitably things that are produced, i.e. things that are pro-duced (brought forward) out of the available natural world. The totality of such things can be referred to as *culture*. Apparatuses are part of a culture, consequently this culture is recognizable in them. It is true that the word *apparatus* is also occasionally applied to natural phenomena, e.g. when speaking of the hearing apparatus of animals. Such usage is, however, metaphorical: We call these organs hearing apparatus because they 'lie in wait for sounds' – thus applying a cultural term to the natural world; if there were no apparatuses in our culture, we should not refer to such organs in that way.

Roughly speaking, two kinds of cultural objects can be distinguished: the ones that are good for consumption (consumer goods) and the ones that are good for produc-ing consumer goods (tools). The two have in common that they are 'good' for something: They are 'valuable', they are as they should be, i.e. they have been produced inten-tionally. This is the difference between the natural and the cultural sciences: The cultural sciences pursue the intentions hiding behind things. They enquire not only 'Why?' but also 'What for?', and consequently they also pursue the intention behind the camera. Judged by this criterion, the camera is a tool whose intention is to produce photo-graphs. As soon as one defines apparatuses as tools, how-ever, doubts arise. Is a photograph a consumer item like a shoe or an apple? And hence, is a camera a tool like a needle or a pair of scissors?

Tools in the usual sense tear objects from the natural world in order to bring them to the place (produce them) where the human being is. In this process they change the form of these objects: They imprint a new, intentional form onto them. They 'inform' them: The object acquires an unnatural, improbable form; it becomes cultural. This production and information of natural objects is called 'work' and its result is called 'a work'. Many works, such as apples, are admittedly produced, but have hardly been informed; others, such as shoes, are strongly informed, they have a form that is developed from animal skins (leather). Apple-producing (-picking) scissors are tools that inform very little; shoe-producing needles are tools that inform a lot. Is the camera then a kind of needle since photographs carry information?

Tools in the usual sense are extensions of human organs: extended teeth, fingers, hands, arms, legs. As they extend they reach further into the natural world and tear objects from it more powerfully and more quickly than the body could do on its own. They simulate the organ they are extended from: An arrow simulates the fingers, a hammer the fist, a pick the toe. They are 'empirical'. With the Industrial Revolution, however, tools were no longer limited to empirical simulations; they grasped hold of scientific theories: They became 'technical'. As a result they became stronger, bigger and more expensive, their works became cheaper and more numerous, and from then on they were called 'machines' . Is the camera then a machine because it appears to simulate the eye and in the process reaches back to a theory of optics? A 'seeing machine'?

When tools in the usual sense became machines, their relationship to human beings was reversed. Prior to the Industrial Revolution the human being was surrounded

by tools, afterwards the machine was surrounded by human beings. Previously the tool was the variable and the human being the constant, subsequently the human being became the variable and the machine the constant. Previously the tool functioned as a function of the human being, subsequently the human being as a function of the machine. Is the same true for the camera as for the machine?

The size and high price of machines meant that only capitalists were able to own them. Most human beings worked as a function of machines: the proletariat. Humanity was divided into two classes, that of the machine owners for whose benefit the machines worked, and that of the class of proletarians who worked as a function of the use of machines. Is that true now for the camera? Is the photographer a proletarian, and are there photocapitalists?

All these questions, even though they are 'good questions', do not appear to grasp the basic function of apparatuses. Of course: Apparatuses simulate technical organs. Of course: Human beings function as a function of apparatuses. Of course: There are intentions and interests concealed behind apparatuses. But this is not the decisive thing about them. All these questions lose sight of the basic function of apparatuses because they arise out of the industrial context. Apparatuses, though the result of industry, point beyond the industrial context towards post-industrial society. Therefore a formulation of things based on industry (like that of the Marxists, for example) is no longer competent to deal with apparatuses and misses what they are about. We have to reach out for new categories in order to be able to tackle apparatuses and define what they are.

The basic category of industrial society is work: Tools and machines work by tearing objects from the natural world and informing them, i.e. changing the world. But apparatuses do not work in that sense. Their intention is not to change the world but to change the meaning of the world. Their intention is symbolic. Photographers do not work in the industrial sense, and there is no point in trying to call them workers or proletarians. As most human beings currently work on and in apparatuses, talk of the proletariat is beside the point. The categories of cultural criticism must be rethought.

Photographers, it is true, do not work but they do do something: They create, process and store symbols. There have always been people who have done such things: writers, painters, composers, book-keepers, managers. In the process these people have produced objects: books, paintings, scores, balance-sheets, plans – objects that have not been consumed but that have served as carriers of information. They were read, looked at, played, taken into account, used as the basis for decisions. They were not an end but a means. Currently this sort of activity is being taken over by apparatuses. As a result, the objects of information created in this way are becoming more and more efficient and more and more extensive, and they are able to program and control all the work in the old sense. Therefore, most human beings are currently employed on and in work-programming and work-controlling apparatuses. Prior to the invention of apparatus, this kind of activity was seen as being the 'service sector', as 'tertiary', as 'brain work', in short as peripheral. Nowadays it is at the centre of things. Therefore in cultural analysis the category 'work' must be replaced by the category 'information'.

If one considers the camera (and apparatuses in general) in this sense, one sees that the camera produces symbols: symbolic surfaces that have in a certain way been prescribed for it. The camera is programmed to produce photographs, and every photograph is a realization of one of the possibilities contained within the program of the camera. The number of such possibilities is large, but it is nevertheless finite: It is the sum of all those photographs that can be taken by a camera. It is true that one can, in theory, take a photograph over and over again in the same or a very similar way, but this is not important for the process of taking photographs. Such images are 'redundant': They carry no new information and are superfluous. In the following, no account will be taken of redundant photographs since the phrase 'taking photographs' will be limited to the production of informative images. As a result, it is true, the taking of snapshots will largely fall outside the scope of this analysis.

With every (informative) photograph, the photographic program becomes poorer by one possibility while the photographic universe becomes richer by one realization. Photographers endeavour to exhaust the photographic program by realizing all their possibilities. But this program is rich and there is no way of getting an overview of it. Thus photographers attempt to find the possibilities not yet discovered within it: They handle the camera, turn it this way and that, look into it and through it. If they look through the camera out into the world, this is not because the world interests them but because they are pursuing new possibilities of producing information and evaluating the photographic program. Their interest is concentrated on the camera; for them, the world is purely a pretext for the realization of camera possibilities.

In short: They are not working, they do not want to change the world, but they are in search of information.

Such activity can be compared to playing chess. Chess-players too pursue new possibilities in the program of chess, new moves. Just as they play with chess-pieces, photographers play with the camera. The camera is not a tool but a plaything, and a photographer is not a worker but a player: not *Homo faber* but *Homo ludens*. Yet photographers do not play with their plaything but against it. They creep into the camera in order to bring to light the tricks concealed within. Unlike manual workers surrounded by their tools and industrial workers standing at their machines, photographers are inside their apparatus and bound up with it. This is a new kind of function in which human beings are neither the constant nor the variable but in which human beings and apparatus merge into a unity. It is therefore appropriate to call photographers functionaries.

The program of the camera has to be rich, otherwise the game would soon be over. The possibilities contained within it have to transcend the ability of the functionary to exhaust them, i.e. the competence of the camera has to be greater than that of its functionaries. No photographer, not even the totality of all photographers, can entirely get to the bottom of what a correctly programmed camera is up to. It is a black box.

It is precisely the obscurity of the box which motivates photographers to take photographs. They lose themselves, it is true, inside the camera in search of possibilities, but they can nevertheless control the box. For they know how to feed the camera (they know the input of the box), and likewise they know how to get it to spit out photographs (they know the output of the box). Therefore the camera

does what the photographer wants it to do, even though the photographer does not know what is going on inside the camera. This is precisely what is characteristic of the functioning of apparatuses: The functionary controls the apparatus thanks to the control of its exterior (the input and output) and is controlled by it thanks to the impenetrability of its interior. To put it another way: Functionaries control a game over which they have no competence. The world of Kafka, in fact.

As will be shown later, the programs of apparatuses consist of symbols. Functioning therefore means playing with symbols and combining them. An anachronistic example may serve as an illustration: Writers can be considered functionaries of the apparatus 'language' that plays with the symbols contained within the language program – with words – by combining them. Their intention is to exhaust the language program and to enrich literature, the universe of language. The example is anachronistic because language is not an apparatus; it was not created as a simulation of a body organ and it is not based, in its creation, on any scientific theories at all. Nevertheless, language can nowadays be 'apparatusized': 'Word processors' can replace writers. In their games with words, writers inform pages – they imprint letters on them – something a word processor can also do and, even though this is 'automatic', i.e. happens by chance, it can, in the long run, create the same information as a writer.

But there are apparatuses that are capable of playing quite different games. While writers and word processors inform statically (the symbols that they imprint on pages signify conventional sounds), there are also apparatuses that inform dynamically: The symbols that they imprint on objects signify specific movements (e.g. work move-

ments) and the objects informed in this way decode these symbols and move according to the program. These 'smart tools' replace human work and liberate human beings from the obligation to work: From then on they are free to play.

The camera illustrates this robotization of work and this liberation of human beings for play. It is a smart tool because it creates images automatically. Photographers no longer need, like painters, to concentrate on a brush but can devote themselves entirely to playing with the camera. The work to be carried out, imprinting the image onto the surface, happens automatically: The tool side of the camera is 'done with', the human being is now only engaged with the play side of the camera.

There are therefore two interweaving programs in the camera. One of them motivates the camera into taking pictures; the other one permits the photographer to play. Beyond these are further programs – that of the photographic industry that programmed the camera; that of the industrial complex that programmed the photographic industry; that of the socio-economic system that programmed the industrial complex; and so on. Of course, there can be no 'final' program of a 'final' apparatus since every program requires a metaprogram by which it is programmed. The hierarchy of programs is open at the top.

Every program functions as a function of a metaprogram and the programmers of a program are functionaries of this metaprogram. Consequently, no-one can own apparatuses in the sense that human beings program apparatuses for their own private purposes. Because apparatuses are not machines. The camera functions on behalf of the photographic industry, which functions on behalf of the industrial complex, which functions on behalf of the

socio-economic apparatus, and so on. The question of ownership of the apparatus is therefore irrelevant; the real issue here is who develops its program. The following explanation shows that there is little point in wanting to own an apparatus, as if it were just any other object.

It is true that many apparatuses are hard objects. A camera is constructed out of metal, glass, plastic, etc. But it is not this hardness that makes it capable of being played with, nor is it the wood of the chessboard and the chess-pieces that make the game possible, but the rules of the game, the chess program. What one pays for when buying a camera is not so much the metal or the plastic but the program that makes the camera capable of creating images in the first place– just as generally the hard side of apparatuses, the *hardware*, is getting cheaper all the time, the soft side of them, the *software*, is getting more expensive all the time. One can see from the softest of the apparatus, e.g. political apparatus, what is characteristic of the whole of post-industrial society: It is not those who own the hard object who have something of value at their disposal but those who control its soft program. The soft symbol, not the hard object, is valuable: a revaluation of all values.

Power has moved from the owner of objects to the programmer and the operator. The game of using symbols has become a power game – a hierarchical power game. Photographers have power over those who look at their photographs, they program their actions; and the camera has power over the photographers, it programs their acts. This shift of power from the material to the symbolic is what characterizes what we call the 'information society' and 'post-industrial imperialism'. Look at Japan: It owns neither raw materials nor energy – its power lies in programming, 'data processing', information, symbols.

These reflections make it possible to attempt the following definition of the term 'apparatus': It is a complex plaything, so complex that those playing with it are not able to get to the bottom of it; its game consists of combinations of the symbols contained within its program; at the same time this program was installed by a metaprogram and the game results in further programs; whereas fully automated apparatuses can do without human intervention, many apparatuses require the human being as a player and a functionary.

Apparatuses were invented to simulate specific thought processes. Only now (following the invention of the computer), and as it were with hindsight, is it becoming clear what kind of thought processes we are dealing with in the case of all apparatuses. That is: thinking expressed in numbers. All apparatuses (not just computers) are calculating machines and in this sense 'artificial intelligences', the camera included, even if their inventors were not able to account for this. In all apparatuses (including the camera), thinking in numbers overrides linear, historical thinking. This tendency to subordinate thinking in letters to thinking in numbers has been the norm in scientific discourse since Descartes; it has been a question of bringing thought into line with 'extended matter' constructed out of punctuated elements. Only numbers are suited to a process of 'bringing thinking matter into line with extended matter'. Since Descartes at least (perhaps since Nicholas of Cusa) scientific discourse has tended towards the re-encoding of thought into numbers, but only since the camera has this tendency become materially possible: The camera (like all apparatuses that followed it) is computational thinking flowing into hardware. Hence the quantum (computational) structure of all the movements

and functions of the apparatus.

In short: Apparatuses are black boxes that simulate thinking in the sense of a combinatory game using number-like symbols; at the same time, they mechanize this thinking in such a way that, in future, human beings will become less and less competent to deal with it and have to rely more and more on apparatuses. Apparatuses are scientific black boxes that carry out this type of thinking better than human beings because they are better at playing (more quickly and with fewer errors) with number-like symbols. Even apparatuses that are not fully automated (those that need human beings as players and functionaries) play and function better than the human beings that operate them. This has to be the starting point for any consideration of the act of photography.

The Gesture of Photography

If one observes the movements of a human being in pos-
session of a camera (or of a camera in possession of a
human being), the impression given is of someone lying
in wait. This is the ancient act of stalking which goes back
to the palaeolithic hunter in the tundra. Yet photographers
are not pursuing their game in the open savanna but in
the jungle of cultural objects, and their tracks can be
traced through this artificial forest. The acts of resistance
on the part of culture, the cultural conditionality of
things, can be seen in the act of photography, and this
can, in theory, be read off from photographs themselves.

The photographic jungle consists of cultural objects,
i.e. objects that were 'intentionally produced'. Each of
these objects obscures photographers' views of their prey.
Stalking their way through these objects, avoiding the
intention concealed within them, photographers wish to
liberate themselves from their cultural condition and to
snap their prey unconditionally. For this reason, the
photographic tracks through the jungle of Western culture
take a different route from those through the jungle of
Japan or those through an underdeveloped country. In
theory, cultural conditions seem, to a certain extent, to
emerge 'in negative' in the photograph, as acts of resist-
ance that have been avoided. Criticism of photography
should be able to reconstruct these cultural conditions
from the photographs – not just in the case of documen-
tary pictures and photojournalism, where the cultural
condition is the prey to be snapped – because the struc-

ture of the cultural condition is captured in the act of photography rather than in the object being photographed.

Such a decoding of the cultural conditions of photography is, however, almost impossible since what appears in the photograph are the categories of the camera which ensnare the cultural conditions like a net with a limited view through its mesh. This is characteristic of all functions: The categories of the apparatus adjust to cultural conditions and filter them. Individual cultural conditions thus disappear from view: The result is a mass culture of cameras adjusted to the norm; in the West, in Japan, in underdeveloped countries – all over the world, everything is photographed through the same categories. Kant and his categories become impossible to avoid.

The categories of the camera are registered on the outside of the camera and can be adjusted there, as long as the camera is not fully automatic. These are the categories of photographic time and space. They are neither Newtonian nor Einsteinian, but they divide time and space into rather clearly separated areas. These areas of time and space are distances from the prey that is to be snapped, views of the 'photographic object' situated at the centre of time and space. For example: one time and space for extreme close-up; one for close-up, another for middle distance, another for long distance; one spatial area for a bird's-eye view, another for a frog's-eye view; another for a toddler's perspective; another for a direct gaze with eyes wide open as in olden days; another for a sidelong glance. Or: one area of time (shutter speed) for a lightning-fast view, another for a quick glance, another for a leisurely gaze, another for a meditative inspection. The act of photography has its movement within this time and space.

On the hunt, photographers change from one form of space and time to another, a process which adjusts the combinations of time-and-space categories. Their stalking is a game of making combinations with the various categories of their camera, and it is the structure of this game – not directly the structure of the cultural condition itself – that we can read off from the photograph.

Photographers select combinations of categories – for example, they may place the camera in such a way that they can shoot their prey with a side-flash from below. It looks here as if photographers could choose freely, as if their cameras were following intention. But the choice is limited to the categories of the camera, and the freedom of the photographer remains a programmed freedom. Whereas the apparatus functions as a function of the photographer's intention, this intention itself functions as a function of the camera's program. It goes without saying that photographers can discover new categories. But then they are straying beyond the act of photography into the metaprogram – of the photographic industry or of their own making – from which cameras are programmed. To put it another way: In the act of photography the camera does the will of the photographer but the photographer has to will what the camera can do.

The same symmetry between the function of the photographer and that of the camera can be perceived in the choice of the 'object' to be photographed. Photographers can photograph everything: a face, a louse, the trace of an atomic particle in a Wilson cloud chamber, a spiral nebula, their own act of photography reflected in the mirror. In reality, however, they can only photograph what can be photographed, i.e. everything located within the program. And the only things that can be photo-

graphed are states of things. Whatever objects photographers wish to photograph, they have to translate them into states of things. Consequently it is true that the choice of the 'object' to be photographed is free, but it also has to be a function of the program of the camera.

In choosing their categories, photographers may think they are bringing their own aesthetic, epistemological or political criteria to bear. They may set out to take artistic, scientific or political images for which the camera is only a means to an end. But what appear to be their criteria for going beyond the camera nevertheless remain subordinate to the camera's program. In order to be able to choose camera-categories, as they are programmed on the camera's exterior, photographers have to 'set' the camera, and that is a technical act, more precisely a conceptual act ('concept', as will be shown later, is a clear and distinct element of linear thought). In order to be able to set the camera for artistic, scientific and political images, photographers have to have some concepts of art, science and politics: How else are they supposed to be able to translate them into an image? There is no such thing as naïve, nonconceptual photography. A photograph is an image of concepts. In this sense, all photographers' criteria are contained within the camera's program.

The possibilities contained within the camera's program are practically inexhaustible. One cannot actually photograph everything that can be photographed. The imagination of the camera is greater than that of every single photographer and that of all photographers put together: This is precisely the challenge to the photographer. Likewise, there are parts of the camera's program that are already well explored. It is true that one can still take new images, but they would be redundant, non-

informative images, similar to those one has seen before. As stated elsewhere, redundant photographs are not of interest in this study; photographers in the sense intended here are in pursuit of possibilities that are still unexplored in the camera's program, in pursuit of informative, improbable images that have not been seen before.

Basically, therefore, photographers wish to produce states of things that have never existed before; they pursue these states, not out there in the world, since for them the world is only a pretext for the states of things that are to be produced, but amongst the possibilities contained within the camera's program. To this extent, the traditional distinction between realism and idealism is overturned in the case of photography: It is not the world out there that is real, nor is the concept within the camera's program – only the photograph is real. The program of the world and the camera are only preconditions for the image, possibilities to be realized. We are dealing here with a reversal of the vector of significance: It is not the significance that is real but the signifier, the information, the symbol, and this reversal of the vector of significance is characteristic of everything to do with apparatus and characteristic of the post-industrial world in general.

The act of photography is divided into a sequence of leaps in which photographers overcome the invisible hurdles of individual time-and-space categories. If they are confronted by one of these hurdles (e.g. on the borderline between close-up and long shot), they hesitate and are faced with the decision about how to set the camera. (In the case of fully automatic cameras this leap, this quantum nature of photography, has become totally invisible – the leaps take place within the micro-electronic 'nervous system' of the camera.) This type of jump-start pursuit is

called 'doubt'. Photographers have doubts, but these are not of a scientific, religious or existential sort; rather, they are doubts in the sense of a new sort of doubt in which stopping short and taking a decision are reduced to grains – a quantum, atomized doubt. Each time photographers are confronted by a hurdle, they discover that the viewpoint they have adopted is concentrated on the 'object' and that the camera offers any number of different viewpoints. They discover the multiplicity and the equality of viewpoints in relation to their 'object'. They discover that it is not a matter of adopting a perfect viewpoint but of realizing as many viewpoints as possible. Their choice is therefore not of a qualitative, but of a quantitive kind. 'Vivre le plus, non pas le mieux.'

The act of photography is that of 'phenomenological doubt', to the extent that it attempts to approach phenomena from any number of viewpoints. But the 'mathesis' of this doubt (its deep structure) is prescribed by the camera's program. Two aspects are decisive for this doubt. First: Photographers' practice is hostile to ideology. Ideology is the insistence on a single viewpoint thought to be perfect. Photographers act in a post-ideological way even when they think they are serving an ideology. Second: Photographers' practice is fixed to a program. Photographers can only act within the program of the camera, even when they think they are acting in opposition to this program. This is true of all post-industrial acts: They are 'phenomenological' in the sense of being hostile to ideology, and they are programmed acts. Thus it is a mistake to talk of a drift towards ideology on the part of mass culture (e.g. on the part of mass photography). Programming is post-ideological manipulation.

Ultimately, there is a final decision taken in the act of

photography: pressing the shutter release – just like the American President ultimately pressing the red button. In reality, however, these final decisions are only the last of a series of part-decisions resembling grains of sand: in the case of the American President, the final straw that breaks the camel's back: a quantum-decision. As consequently, no decision is really 'decisive', but part of a series of clear and distinct quantum-decisions, likewise only a series of photographs can testify to the photographer's intention. For no single photograph is actually decisive; even the 'final decision' finds itself reduced to a grain in the photo-graph.

Photographers attempt to escape this granulation by selecting some of their images in the same way as a film director cuts strips of film. But even then their choice is quantum, since they cannot help highlighting elements of a series of clear and distinct surfaces. Even in this seem-ingly post-camera situation of choosing the photograph, one can see the quantum, atomized structure of every-thing to do with photography (and everything to with apparatus pure and simple).

To summarize: The act of photography is like going on a hunt in which photographer and camera merge into one indivisible function. This is a hunt for new states of things, situations never seen before, for the improbable, for information. The structure of the act of photography is a quantum one: a doubt made up of points of hesitation and points of decision-making. We are dealing here with a typically post-industrial act: It is post-ideological and pro-grammed, an act for which reality is information, not the significance of this information. And the same is true not only of the photographer but of all functionaries, from a bank cashier to the American President.

The act of photography results in photographs such as we nowadays are being flooded with on all sides. Hence a consideration of this act can serve as an introduction to these surfaces whose presence is ubiquitous.

The Photograph

Photographs are ubiquitous: in albums, magazines, books, shop windows, on bill-boards, carrier bags, cans. What does this signify? Thus far, reflection has suggested the thesis (still to be examined) that these images signify concepts in a program and that they program society to act as though under a secondary magic spell. However, for people who look at photographs naïvely they signify something different, i.e. states of things that have been reflected onto surfaces. For these people, photographs represent the world itself. Admittedly, such naïve observers will concede that the states of things are reflected onto surfaces from specific points of view but they won't worry too much about that. Any philosophy of photography will therefore seem to them a complete waste of mental energy.

Such observers tacitly accept that they are looking through the photographs at the world out there and that therefore the photographic universe and the world out there are one and the same (which still amounts to a rudimentary philosophy of photography). But is this the case? The naïve observer sees that in the photographic universe one is faced with both black-and-white and coloured states of things. But are there any such black-and-white and coloured states of things in the world out there? As soon as naïve observers ask this question, they are embarking on the very philosophy of photography that they were trying to avoid.

There cannot be black-and-white states of things in the

world because black-and-white cases are borderline, 'ideal cases': black is the total absence of all oscillations contained in light, white the total presence of all the elements of oscillation. 'Black' and 'white' are concepts, e.g. theoretical concepts of optics. As black-and-white states of things are theoretical, they can never actually exist in the world. But black-and-white photographs do actually exist because they are images of concepts belonging to the theory of optics, i.e. they arise out of this theory.

Black and white do not exist, but they ought to exist since, if we could see the world in black and white, it would be accessible to logical analysis. In such a world everything would be either black or white or a mixture of both. The disadvantage of such a black-and-white way of looking at the world, of course, would be that this mixture would turn out to be not coloured but grey. Grey is the colour of theory: which shows that one cannot reconstruct the world anymore from a theoretical analysis. Black-and-white photographs illustrate this fact: They are grey, they are theoretical images.

Long before the invention of the photograph, one attempted to imagine the world in black and white. Here are two examples of this pre-photographic manicheism: Abstractions were made from the world of judgements distinguishing those that were 'true' and those that were 'false', and from these abstractions Aristotelian logic was constructed with its identity, difference and excluded middle. Modern science based on this logic functions despite the fact that no judgement is ever either completely true or completely false and even though every true judgement is reduced to nothing when subjected to logical analysis. The second example: Abstractions were made from the world of actions distinguishing the 'good'

from the 'bad' and religious and political ideologies were constructed from these abstractions. The social systems based on them actually function despite the fact that no action is ever either completely good or completely bad and despite the fact that every action is reduced to a puppet-like motion when subjected to ideological analysis.

Black-and-white photographs belong to the same sort of manicheism, only they involve the use of cameras. And they too actually function: They translate a theory of optics into an image and thereby put a magic spell on this theory and re-encode theoretical concepts like 'black' and 'white' into states of things. Black-and-white photographs embody the magic of theoretical thought since they transform the linear discourse of theory into surfaces. Herein lies their peculiar beauty, which is the beauty of the conceptual universe. Many photographers therefore also prefer black-and-white photographs to colour photographs because they more clearly reveal the actual significance of the photograph, i.e. the world of concepts.

The first photographs were black and white and still clearly acknowledged their origin in the theory of optics. However, with the advance of another theory, that of chemistry, colour photographs were also finally possible. It looked as if photographs first abstracted the colours from the world in order to smuggle them back in. In reality, however, the colours of photographs are at least as theoretical as black and white. The green of a photographed field, for example, is an image of the concept 'green', just as it occurs in chemical theory, and the camera (or rather the film inserted into it) is programmed to translate this concept into the image. It is true that there is a very indirect, distant connection between the green of the photograph and the green of the field, since the chemical

concept 'green' is based on ideas that have been drawn from the world; but between the green of the photograph and the green of the field a whole series of complex encodings have crept in, a series that is more complex than that which connects the grey of the field photographed in black and white with the green of the field. In this sense the field photographed in green is more abstract than the one in grey. Colour photographs are on a higher level of abstraction than black-and-white ones. Black-and-white photographs are more concrete and in this sense more true: They reveal their theoretical origin more clearly, and vice versa: The 'more genuine' the colours of the photograph become, the more untruthful they are, the more they conceal their theoretical origin.

What is true of the colours of photographs is also true of all of the other elements of photographs. They all represent transcoded concepts that claim to have been reflected automatically from the world onto the surface. It is precisely this deception that has to be decoded so as to identify the true significance of the photograph, i.e. programmed concepts, and to reveal that in the case of the photograph one is dealing with a symbolic complex made up of abstract concepts, dealing with discourses re-encoded into symbolic states of things.

Here we must agree about what we mean by 'decode'. What am I doing when I decode texts encoded in Latin characters? Am I decoding the meaning of the characters, i.e. the sound conventions of a spoken language? Am I decoding the meaning of the words made up of these characters? The meaning of the sentences made up of these words? Or do I have to look further – for the writers' intentions, the cultural context behind them? What am I doing when I decode photographs? Am I

decoding the meaning of 'green', i.e. a concept from the discourse of chemical theory? Or do I have to look further, into the photographers' intentions and their cultural context? When will I decide that I have had enough of decoding?

Putting the question in this way, there is no satisfactory solution to decoding. One would be drawn into an endless process since every level of decoding would reveal another one waiting to be decoded. Every symbol is just the tip of an iceberg in the ocean of cultural consensus, and even if one got right to the bottom of decoding a single message, the whole of culture past and present would be revealed. Carried out in this 'radical' fashion, criticism of a single message would turn out to be criticism of culture in general.

In the case of the photograph, this descent into infinite regression can be avoided, however, since one can be satisfied with recording the encoding intentions at work within the 'photographer/camera' complex. Once one has read off this encoding from the photograph, it can then be considered to have been decoded. Provided, of course, that a distinction is made between the photographer's intention and the camera's program. In actual fact, these two factors are interconnected and cannot be separated; but theoretically, in order to carry out the decoding, they can be considered as separate in every single photograph.

Reduced to basic elements, photographers' intentions are as follows: first, to encode their concepts of the world into images; second, to do this by using a camera; third, to show the images produced in this way to others so that they can serve as models for their experience, knowledge, judgement and actions; fourth, to make these models as permanent as possible. In short: Photographers' intentions

are to inform others and through their photographs to immortalize themselves in the memory of others. For photographers, their concepts (and the ideas signified by these concepts) are the main *raisons d'être* for taking photographs, and the camera's program is in the service of these *raisons d'être*.

Likewise reduced to its basic elements, the camera's program is as follows: first, to place its inherent capabilities into the image; second, to make use of a photographer for this purpose, except in borderline cases of total automation (for example, in the case of satellite photographs); third, to distribute the images produced in this way so that society is in a feedback relationship to the camera which makes it possible for the camera to improve progressively; fourth, to produce better and better images. In short: The camera's program provides for the realization of its capabilities and, in the process, for the use of society as a feedback mechanism for its progressive improvement. As mentioned previously, there are further programs behind this one (that of the photographic industry, of the industrial complex, of the socio-economic apparatuses), through the entire hierarchy of which there flows the enormous intention of programming society to act in the interests of the progressive improvement of these apparatuses. This intention can be seen in every single photograph and can be decoded from it.

A comparison of the photographer's intention and the intention of the camera shows that there are points where both converge and others where they diverge. At the points of convergence they work together; at the points of divergence they conflict with one another. Every single photograph is the result, at one and the same time, of co-operation and of conflict between camera and photo-

grapher. Consequently, a photograph can be considered to have been decoded when one has succeeded in establishing how co-operation and conflict act on one another within it.

The question put to photographs by critics of photography can therefore be formulated as: 'How far have photographers succeeded in subordinating the camera's program to their own intentions, and by what means?' And, vice versa: 'How far has the camera succeeded in redirecting photographers' intentions back to the interests of the camera's program, and by what means?' On the basis of these criteria, the 'best' photographs are those in which photographers win out against the camera's program in the sense of their human intentions, i.e. they subordinate the camera to human intention. It goes without saying that there are 'good' photographs in which the human spirit wins out against the program. But in the photographic universe as a whole, one can see how programs are succeeding more and more in redirecting human intentions in the interests of camera functions. The task of photography criticism should therefore be to identify the way in which human beings are attempting to get a hold over the camera and, on the other hand, the way in which cameras aim to absorb the intentions of human beings within themselves. Of course, we have been unable to achieve criticism of this type up to now for reasons still to be discussed.

(It is true that the heading of this essay is 'The Photograph', but we are dealing with those specific aspects of photographs in which they differ from other technical images. By way of explanation, let's say that the intention of this essay was to indicate the direction for a rational decoding of photographs. The following essay will attempt to make up for this narrow focus.)

To summarize: Like all technical images, photographs are concepts encoded as states of things, including photographers' concepts such as those that have been programmed into the camera. This gives photography critics the task of decoding these two interweaving codes in any photograph. Photographers encode their concepts as photographic images so as to give others information, so as to produce models for them and thereby to become immortal in the memory of others. The camera encodes the concepts programmed into it as images in order to program society to act as a feedback mechanism in the interests of progressive camera improvement. If photographic criticism succeeds in unravelling these two intentions of photographs, then the photographic messages will be decoded. If photography critics do not succeed in this task, photographs remain undecoded and appear to be representations of states of things in the world out there, just as if they reflected 'themselves' onto a surface. Looked at uncritically like this, they accomplish their task perfectly: programming society to act as though under a magic spell for the benefit of cameras.

The Distribution of Photographs

The characteristic that distinguishes photographs from
other technical images is clearly evident as soon as one
looks at the distribution of photographs. The photograph
is an immobile and silent surface patiently waiting to be
distributed by means of reproduction. For this distribu-
tion there is no need of any complicated technical appara-
tus: photographs are loose leaves which can be passed
from hand to hand. There is no need for them to be
stored in technically perfect data-storage systems: They
can be put away in drawers. In order to identify more
clearly these peculiarities of the distribution of photo-
graphs, a few initial observations should be made about
the distribution of information.

Nature as a whole is a system in which information
disintegrates progressively according to the second law of
thermodynamics. Human beings struggle against this
natural entropy not only by receiving information but also
storing and passing it on – (in this respect they differ from
other forms of life) – and also by deliberately creating
information. This specifically human and at the same time
unnatural ability is called 'mind', and culture is its result,
i.e. improbably formed, informed objects.

The process of manipulating information – called
'communication' – is divided into two phases: In the first,
information is created; in the second, it is distributed to
memories in order to be stored there. The first phase is
called 'dialogue', the second 'discourse'. In dialogue, avail-
able information is synthesized into a new phase in which

the information to be synthesized can be located in a single memory (as in 'inner dialogue'); in discourse, the information produced in dialogue is distributed.

Four methods of discourse can be distinguished here: First, the receivers form a semi-circle around the sender, as in the theatre; second, the sender makes use of a series of information conveyors (relay stations), as in the army; third, the sender distributes the information to dialogues which they pass on in an enriched form, as in scientific discourses; fourth, the sender transmits the information into space, as on the radio. Each one of these methods of discourse corresponds to a particular cultural situation – the first corresponds to responsibility, the second to authority, the third to progress, the fourth to massification. The distribution of photographs makes use of the fourth method.

Photographs can, of course, be treated dialogically. One can draw moustaches or obscene symbols on photographic posters and thereby synthesize a new piece of information. But this does not form part of the cameras' programs. Cameras are programmed, as will be shown, purely for the transmission of information, like all image-creating apparatuses (with exceptions such as video or artificial computer images, where dialogues are predicted within their programs).

The photograph is for the time being nothing but a flyer, even if it is in the process of being taken over by electromagnetic technology. As long as it remains attached to paper in the old-fashioned way, however, it can be distributed in the old-fashioned way as well, i.e. independently of film projectors or television screens. The state of being attached like this, as in the old-fashioned way, to a material surface reminds one of the state of being bound

to a screen in the case of ancient images, such as cave paintings or the frescoes in Etruscan tombs. But this 'objectivity' of the photograph is deceptive. If one wants to distribute ancient images, one must convey them from owner to owner; one has to sell or win control over the caves or tombs. For they are unique, valuable as objects; they are 'originals'. Photographs, on the other hand, can be distributed by means of reproduction. The camera creates prototypes (negatives) from which as many stereotypes (copies) as one likes can be produced and distributed – in which case the concept of the original, in the context of the photograph, has scarcely any meaning anymore. As an object, as a thing, the photograph is practically without value; a flyer and no more.

As long as the photograph is not yet electromagnetic, it remains the first of all post-industrial objects. Even though the last vestiges of materiality are attached to photographs, their value does not lie in the thing but in the information on their surface. This is what character-izes the post-industrial: The information, and not the thing, is valuable. Issues of the ownership and distribution of objects (capitalism and socialism) are no longer valid, evading as they do the question of the programming and distribution of information (the information society). It is no longer a matter of owning another pair of shoes or another piece of furniture, but of having another holiday or another school for one's children at one's disposal. Revaluation of all values. Until photographs become elec-tromagnetic, they are a connecting link between indus-trial objects and pure information.

It goes without saying that industrial objects are valu-able precisely because they convey information. A shoe and a piece of furniture are valuable because they are

information-carriers, improbable forms made of leather or wood and metal. But information is impressed into these objects and cannot be detached from them. One can only wear out and consume this information. This is what 'makes' such objects, as objects, valuable, i.e. 'able' to be filled with value. In the case of the photograph on the other hand, the information sits loosely on the surface and can easily be conveyed to another surface. To this extent, the photograph demonstrates the defeat of the material thing and of the concept of 'ownership'. It is not the person who owns a photograph who has power but the person who created the information it conveys. It is not the owner but the programmer of the information who is the powerful one: neo-imperialism. The poster is without value; nobody owns it, it flaps torn in the wind yet the power of the advertising agency remains undiminished nevertheless – the agency can reproduce it. This obliges us to revalue our traditional economic, political, moral, epistemological and aesthetic values.

Electromagnetic photographs, films and television images do not illustrate the devaluation of the material thing nearly as well as photographs attached to paper in the old-fashioned way. If, in the case of such advanced images, the material basis of information has completely disappeared and electromagnetic photographs can be created artificially at will and processed by the receiver as pure information (i.e. the 'pure information society'), in the case of photographs of the old-fashioned type, one still holds something material, flyer-like, in one's hands; this something is without value, treated with contempt – and is becoming less and less valuable and treated with more and more contempt. In the case of classical photographs, there are still valuable bromide prints – even today

the last vestiges of value attach to the 'original photograph' making it more valuable than a reproduction in a newspaper. But the photograph bound to paper nevertheless indicates the first step on the road to the devaluation of the material thing and valuation of information.

Even though the photograph remains a flyer for the time being and therefore can be distributed in the old-fashioned way, gigantic complex apparatuses of photograph distribution have come into being. Attached to the output of the camera, they absorb the images flowing out of the camera and reproduce them endlessly, deluging society with them via thousands of channels. Like all apparatuses, the apparatuses of photograph distribution also have a program by which they program society to act as part of a feedback mechanism. Typical of this program is the division of photographs into various channels, their 'channelling'.

In theory, information can be classified as follows: into indicative information of the type 'A is A', into imperative information of the type 'A must be A', and into optative information of the type 'A may be A'. The classical ideal of the indicative is truth, that of the imperative is goodness, and that of the optative is beauty. This theoretical classification cannot, however, be applied in practice since every scientific indicative has at the same time political and aesthetic aspects, every political imperative has scientific and aesthetic aspects, every optative (work of art) has scientific and political aspects. Nevertheless, the distribution apparatuses practise precisely this theoretical classification.

Thus there are channels for supposedly indicative photographs (e.g. scientific publications and reportage magazines), channels for supposedly imperative photo-

graphs (e.g. political and commercial advertising posters) and channels for supposedly artistic photographs (e.g. galleries and art journals). Of course, the distribution apparatuses also have borderline areas, in which a particular photograph can slip over from one channel to another. The photograph of the moon landing, for example, can slip from an astronomy journal to a US consulate, from there onto an advertising poster for cigarettes and from there finally into an art exhibition. The essential thing is that the photograph, with each switch-over to another channel, takes on a new significance: The scientific significance crosses over into the political, the political into the commercial, the commercial into the artistic. In this respect, the division of photographs into channels is in no way simply a mechanical process but rather an encoding one: The distribution apparatuses impregnate the photograph with the decisive significance for its reception.

Photographers are involved in this encoding. Even at the time of taking photographs they have their eye on a specific channel of the distribution apparatuses and encode their images as a function of this channel. They take photographs for specific scientific publications, specific kinds of illustrated magazine, specific exhibition opportunities. And they do this for two reasons: first, because the channel allows them to reach many receivers; second, because the channel feeds them.

The symbiosis, characteristic of taking photographs, between camera and photographer is mirrored in the channel. For example: Photographers take photographs for a specific newspaper because the newspaper allows them to reach hundreds or thousands of receivers, and because they are being paid by the newspaper; in this, they act in the belief that they are using the newspaper as their

medium. Meanwhile, the newspaper is of the opinion that it is using the photographs as an illustration of its articles in order to be able to program its readers, that accordingly photographers are functionaries of the newspaper apparatus. As photographers know that only those photographs that fit into the newspaper's program will be published, they attempt to fool the newspaper's censorship by surreptitiously smuggling aesthetic, political or epistemological elements into their image. The newspaper on the other hand may well discover these attempts to fool it and publish the photographs anyway because it thinks it can exploit the smuggled elements to enrich its program. And what is true for newspapers is also true for all other channels. Every distributed photograph allows photography criticism to reconstruct the struggle between photographer and channel. It is precisely this that makes photographs into dramatic images.

It is positively disconcerting how often standard photography criticism does not read off from photographs this dramatic confusion of the photographer's intention with the program of the channel. Photography criticism habitually takes it for granted that scientific channels distribute scientific photographs, political channels political photographs, artistic channels artistic photographs. In this respect, the critics function as a function of the channels: They allow them to vanish from the receiver's field of vision. They ignore the fact that the channels determine the significance of the photographs, and thus they give support to the channels' intention to be invisible. Seen in this light, the critics collaborate with the channels against the photographers wanting to fool the channels. We are dealing here with a collaboration in the bad sense, a *trahison des clercs*, a contribution to the victory of the

apparatus over the human being. This is characteristic of the situation of intellectuals in post-industrial society in general. The critics, for example, ask questions such as: 'Is photography art?' – as if these questions were not already being answered automatically by the channels concealing this automatic, programmed channelling and making it all the more effective.

To summarize: Photographs are silent flyers that are distributed by means of reproduction, in fact by means of the massifying channels of gigantic, programmed distribution apparatuses. As objects, their value is negligible; their value lies in the information that they carry loose and open for reproduction on their surface. They are the harbingers of post-industrial society in general: Interest has shifted in their case from the object to the information, and ownership is a category that has become untenable for them. The distribution channels, the 'media', encode their latest significance. This encoding represents a struggle between the distribution apparatus and the photographer. By concealing this struggle, photographic criticism makes the 'media' totally invisible for the receiver of the photograph. In the light of standard photographic criticism, photographs get an uncritical reception and are therefore able to program the receiver to act as if they are under a magic spell; this action flows back in the form of feedback into the programs of the apparatus. This becomes evident as soon as we start to examine the reception of photographs closely.

The Reception of Photographs

Almost everyone today has a camera and takes snaps. Just as almost everyone has learned to write and produce texts. Anyone who is able to write can also read. But anyone who can take snaps does not necessarily have to be able to decode photographs. For us to see why the amateur photographer can be a photographic illiterate, the democratization of the taking of photographs has to be considered – and at the same time, a number of aspects of democracy in general have to be addressed.

Cameras are purchased by people who were programmed into this purchase by the apparatus of advertising. The camera purchased will be the 'latest model': cheaper, more automatic and more efficient than earlier models. As has already been established, this progressive improvement of camera models is based on the feedback mechanism by which those taking snaps feed the photographic industry: The photographic industry learns automatically from the actions of those taking snaps (and from the professional press that constantly supplies it with test results). This is the essence of post-industrial progress. Apparatuses improve by means of social feedback.

Despite the fact that the camera is based on complex scientific and technical principles, it is a very simple matter to make it function. The camera is a structurally complex, but functionally simple, plaything. In this respect, it is the opposite of chess which is a structurally simple, and functionally complex, game: Its rules are easy, but it is difficult to play chess well. Anyone who holds a

camera in their hands can create excellent photographs without having any idea what complex processes they are setting off when they push the button.

People taking snaps are distinguishable from photographers by the pleasure they take in the structural complexity of their plaything. Unlike photographers and chess-players they do not look for 'new moves', for information, for the improbable, but wish to make their functioning simpler and simpler by means of more and more perfect automation. Though impenetrable to them, the automaticity of the camera intoxicates them. Amateur photographers' clubs are places where one gets high on the structural complexities of cameras, where one goes on a photograph-trip – post-industrial opium dens.

Cameras demand that their owners (the ones who are hooked on them) keep on taking snaps, that they produce more and more redundant images. This photo-mania involving the eternal recurrence of the same (or of something very similar) leads eventually to the point where people taking snaps feel they have gone blind: Drug dependency takes over. People taking snaps can now only see the world through the camera and in photographic categories. They are not 'in charge of' taking photographs, they are consumed by the greed of their camera, they have become an extension to the button of their camera. Their actions are automatic camera functions.

A permanent flow of unconsciously created images is the result. They form a camera memory, a databank of automatic functions. Anyone who leafs through the album of a person who takes snaps does not recognize, as it were, the captured experiences, knowledge or values of a human being, but the automatically realized camera possibilities. A journey to Italy documented like this stores the times

and places at which the person taking snaps was induced to press the button, and shows which places the camera has been to and what it did there. This goes for all documentary photography. The documentary photographer, just like the person taking snaps, is interested in continually shooting new scenes from the same old perspective. The photographer in the sense intended here is, on the other hand, interested (like the chess-player) in seeing in continually new ways, i.e. producing new, informative states of things. The evolution of photography, from its origins right up to the present, is a process of increasing awareness of the concept of information: from an appetite for the continually new using the same old method to an interest in continually evolving new methods. Both those taking snaps and documentary photographers, however, have not understood 'information'. What they produce are camera memories, not information, and the better they do it, the more they prove the victory of the camera over the human being.

Anyone who writes has to master the rules of spelling and grammar. Anyone who takes snaps has to adhere to the instructions for use – becoming simpler and simpler – that are programmed to control the output end of the camera. This is democracy in post-industrial society. Therefore people taking snaps are unable to decode photographs: They think photographs are an automatic reflection of the world. This leads to the paradoxical result that the more people take snaps, the more difficult it becomes to decode photographs: Everyone thinks there is no need to decode photographs, since they know how photographs are made and what they mean.

That is not all. The photographs that we are deluged by are seen as contemptible flyers which are cut out of the

newspaper, torn up or used for packing paper; in short: We can do what we like with them. An example: If one sees a scene from the war in Lebanon on television or at the cinema, one knows one has no alternative but to look at it. If one sees it in a newspaper, on the other hand, one can cut it out and keep it, send it to friends with comments or screw it up in rage. One thinks one is thereby able to react in an active way to the scene in Lebanon. The last vestiges of materiality adhering to the photograph give rise to the impression that we are able to act in a historical way towards it. In fact, the actions described are nothing but ritual acts.

The photograph of the scene in Lebanon is an image which, as one's gaze wanders over the surface, produces magical – not historical – relationships between the elements of the image and the reader. In the photograph, rather than seeing historical events with their causes and consequences, we see magical connections. It is true that the photograph illustrates a newspaper article whose structure is linear and which is made up of concepts with meaningful causes and consequences. But we read this article through the photograph: It is not the article that explains the photograph, but the photograph that illustrates the article. This reversal of the text–photo relationship is typically post-industrial and renders any historical action impossible.

Throughout history, texts have explained images; now photographs illustrate articles. Illuminated capital letters used to illustrate Bible texts; now newspaper articles illustrate photographs. The Bible broke the magic spell of capital letters, the photograph is recasting the magic spell of the article. Throughout history, texts dominated, today images dominate. And where technical images dominate,

illiteracy takes on a new role. The illiterate are no longer excluded, as they used to be, from a culture encoded in texts, but participate almost totally in a culture encoded in images. If the complete subordination of texts to images comes about in future, then we shall be faced with a general state of illiteracy, and only a few specialists will learn to read any more. There are signs of this already: 'Johnny can't spell' in the USA, and even the so-called developing countries are in the process of giving up the struggle against illiteracy and providing schools with education in the form of images.

We do not react in a historical way to photographic documentation of the war in Lebanon, but with ritual magic. Cut out the photograph, send it on, screw it up – all these are ritual acts, reactions to the message of the image. This message has a particular background: One element of the image addresses itself to another element, gives significance to another and in return gets its own significance from it. Every element can follow on from that which has followed it. Charged with this background, the surface of the image is 'deified': Everything in it is either good or evil – tanks are evil, children good, Beirut in flames is hell, doctors in white coats are angels. Mysterious powers are circling overhead above the surface of the image, some of which carry names pregnant with value judgement: 'imperialism', 'Zionism', 'terrorism'. Meanwhile, most of them are without names, and they are the ones that give the photograph an indefinable atmosphere, lending it a certain fascination and programming us to act in a ritual fashion.

It goes without saying that we don't just look at the photograph, we also read the article illustrated by it – or at least the headline. As the function of the text is subordi-

nate to the image, the text directs our understanding of the image towards the program of the newspaper. It thereby does not explain the image, it confirms it. Besides, we are by now sick and tired of explanations and prefer to stick to the photograph that releases us from the necessity for conceptual, explanatory thought and absolves us from the bother of going into the causes and consequences of the war in Lebanon: In the image we see with our own eyes what the war looks like. The text simply consists of instructions as to how we are to see.

The reality of the war in Lebanon, as all reality in general, is in the image. The vector of significance has been reversed; reality has slipped into being a symbol, has entered the magic universe of the symbolism of images. The question of the significance of symbols is beside the point – a 'metaphysical' question in the worst sense of the word – and symbols that have become undecodable in this way suppress our historical consciousness, our critical awareness: This is the function that they have been programmed for.

Thus the photograph becomes the model for its receivers' actions. They react in a ritual fashion to its message in order to placate the powers of fate circling overhead above the surface of the image. Here's another example: The photographic poster of a toothbrush summons up the secret power of 'tooth-decay', and from then on it lies in wait for us. We buy a toothbrush in order to carry out the ritual of brushing our teeth and to escape the power of 'tooth-decay' lying in wait for us. We make a sacrifice to the god. It is true that we can look up 'tooth-decay' in a dictionary, but the dictionary has become a pretext for the photographic poster: It will not explain the photographic poster, but confirm it. We will buy the

toothbrush whatever the dictionary says, because we are programmed to carry out this purchase. The lexi-context has become a caption for the photograph: Even with the support of historical information we are acting as if we are under a magic spell.

Our magical-ritual acts are nevertheless not those of Native Americans, but those of functionaries in a post-industrial society. Both Native Americans and functionaries believe in the reality of images, but functionaries do this out of bad faith. After all, they have learned to write at school and consequently should know better. Functionaries have a historical consciousness and critical awareness but they suppress these. They know that the war in Lebanon is not a clash between good and evil but that specific causes have specific consequences there. They know that the toothbrush is not a sacred object but a product of Western history. But they have to suppress their superior knowledge of this. How else would they buy toothbrushes, have opinions about the war in Lebanon, file reports, fill in forms, go on holiday, take retirement – in short, how would they function? The photograph here serves the suspension of critical faculties, it serves the process of functionality.

Of course, critical awareness can still be awakened so as to make the photograph transparent. Then the photograph of Lebanon becomes transparent as regards its newspaper program and the program behind it belonging to the political party programming the newspaper. Then the photograph of the toothbrush becomes transparent as regards the program of the advertising agency and the program behind it belonging to the toothbrush industry. And the powers of 'imperialism', 'Zionism', 'terrorism' and 'tooth-decay' are revealed as concepts contained within

these programs. But this critical exercise does not necessarily lead to a disenchantment of the images. That is, it can itself have been put under a magic spell, thereby becoming 'functional'. The cultural criticism of the Frankfurt School is an example of such a second-order paganism: Behind the images it uncovers secret, superhuman powers at work (e.g. capitalism) that have maliciously created all these programs instead of taking it for granted that the programming proceeds in a mindless automatic fashion. A thoroughly disconcerting process in which, behind the ghosts that have been exorcized, more and more new ones are summoned up.

To summarize: Photographs are received as objects without value that everyone can produce and that everyone can do what they like with. In fact, however, we are manipulated by photographs and programmed to act in a ritual fashion in the service of a feedback mechanism for the benefit of cameras. Photographs suppress our critical awareness in order to make us forget the mindless absurdity of the process of functionality, and it is only thanks to this suppression that functionality is possible at all. Thus photographs form a magic circle around us in the shape of the photographic universe. What we need is to break this circle.

The Photographic Universe

As inhabitants of the photographic universe we have
become accustomed to photographs: They have grown
familiar to us. We no longer take any notice of most
photographs, concealed as they are by habit; in the same
way, we ignore everything familiar in our environment and
only notice what has changed. Change is informative, the
familiar redundant. What we are surrounded by above all
are redundant photographs – and this is the case despite
the fact that every day new illustrated newspapers appear
on our breakfast tables, every week new posters appear on
city walls and new advertising photographs appear in shop
displays. It is precisely this permanently changing situation
that we have become accustomed to: One redundant
photograph displaces another redundant photograph. As
such, the changing situation is familiar, redundant;
'progress' has become uninformative, run-of-the-mill.
What would be informative, exceptional, exciting for us
would be a standstill situation: to find the same news-
papers on our breakfast tables every day or to see the same
posters on city walls for months on end. That would
surprise and shock us. Photographs permanently displacing
one another according to a program are redundant pre-
cisely because they are always 'new', precisely because they
automatically exhaust the possibilities of the photographic
program. This is therefore also the challenge for the photo-
grapher: to oppose the flood of redundancy with informa-
tive images.

It is not only the permanently changing situation of the

photographic universe but also its gaudiness that has become commonplace. We are hardly aware how astonishing the colours of our environment would be to our grandfathers. In the nineteenth century the world was grey: walls, newspapers, books, shirts, tools, all these varied between black and white merging together into grey – as in the case of printed texts. Now everything cries out in all imaginable colours, but it cries out to deaf ears. We have become accustomed to visual pollution; it passes through our eyes and our consciousnesses without being noticed. It penetrates subliminal regions, where it functions and programs our actions.

If one compares the colour of our own world with that of the Middle Ages or of non-European cultures, one is faced with the difference that the colours of the Middle Ages and those of 'exotic' cultures are magic symbols signifying mythical elements, whereas for us they are mythical symbols at work on a theoretical level, elements of programs. For example, 'red' in the Middle Ages signified the danger of being swallowed up by Hell. Similarly, for us 'red' at traffic lights still signifies 'danger', but programmed in such a way that we automatically put our foot on the brake without at the same time engaging our consciousness. All that emerges from the subliminal programming of the colours of the photographic universe are merely ritual, automatic actions.

However, this chameleon-like nature of the photographic universe, the changing gaudiness of it, is only one of its main characteristics, a superficial feature. In accordance with its deeper structure, the photographic universe is grainy; it changes its appearance and colour as a mosaic might change in which the individual little pieces are continually being replaced. The photographic universe is

made up of such little pieces, made up of quanta, and is calculable (calculus = little piece or 'particle') – an atomized, democratic universe, a jigsaw puzzle.

The quantum-like structure of the photographic universe is not surprising, since it has arisen out of the act of photography, whose quantum-like character has already been discussed. Yet an examination of the photographic universe allows us to see the deeper reason for the grainy character of all aspects of photography. It reveals, for example, that the atomized, punctuated structure is characteristic of all things relating to apparatus, and that even those camera functions that appear to slide (e.g. film and television pictures) are actually based on punctuated structures. In the world of apparatus, all 'waves' are made up of grains, and all 'processes' are made up of punctuated situations.

This is because apparatuses are simulations of thought, playthings that play at 'thinking', and they simulate human thought processes, not for example in the way one understands thought corresponding to introspection or the insights of psychology and physiology, but in the way one understands thought as described in the Cartesian model. According to Descartes, thought consists of clear and distinct elements (concepts) that are combined in the thought process like beads on an abacus, in which every concept signifies a point in the extended world out there. If every point could be assigned a concept, then thought would be omniscient and at the same time omnipotent. For thought processes would then symbolically direct processes out there. Unfortunately this omniscience and omnipotence are impossible, because the structure of thought is not adequate to deal with the structure of extended matter. If, for example, the points in the

extended ('concrete') world grow together, leaving no gaps, then distinct concepts in thought are interrupted by intervals through which most of the points escape. Descartes hoped to overcome this inadequacy of the network of thought with the help of God and analytic geometry, but he did not succeed.

Apparatuses, meanwhile, these simulations of Cartesian thought, have succeeded. They are omniscient and omnipotent in their universes. For in these universes, a concept, an element of the program of the apparatus, is actually assigned to every point, every element of the universe. This can be seen most clearly in the case of computers and their universes. But it can also be seen in the case of the photographic universe. To every photograph there corresponds a clear and distinct element in the camera program. Every photograph thereby corresponds to a specific combination of elements in programs. Thanks to this bi-univocal relationship between universe and program, in which a photograph corresponds to every point in the program and a point in the program to every photograph, cameras are omniscient and omnipotent in the photographic universe. But they also have to pay a high price for their omniscience and omnipotence, this price being the reversal of the vectors of significance. That is: Concepts no longer signify the world out there (as in the Cartesian model); instead, the universe signifies the program within cameras. The program does not signify the photograph, the photograph signifies the elements of the program (concepts). In the case of cameras, we are therefore dealing with an absurd omniscience and an absurd omnipotence: Cameras know everything and are able to do everything in a universe that was programmed in advance for this knowledge and ability.

This is the place to define the term 'program'. To this end, all human involvement in the program – that struggle between the function of the program and human intention that was the subject of the previous essay - should be bracketed out. The program to be defined is a completely automatic one: a combination game based on chance. As a particularly simple example of a program, one can cite the throw of dice combining the elements '1' to '6'. Every throw is random, cannot be predicted: but over time every sixth throw is necessarily a '1'. Put another way, all possible combinations are realized by chance, but over time all possible combinations are necessarily realized. If, for example, an atomic war is entered into the program of any apparatus as a possibility, then it will happen by chance, but necessarily someday. In this subhumanly mindless sense, apparatuses 'think' by means of chance combinations. In this sense they are omniscient and omnipotent in their universes.

The photographic universe, like the one by which we are currently surrounded, is a chance realization of a number of possibilities contained within camera programs which corresponds point for point to a specific situation in a combination game. As other programmed possibilities will be realized by chance in future, the photographic universe is in a permanent state of flux and within it one photograph permanently displaces another. Every given situation in the photographic universe corresponds to a 'throw' in the combination game, i.e. point for point, photograph for photograph. But these are totally redundant photos. The informative photographs of photographers consciously playing against the program signify breakthroughs in the photographic universe – and are not predicted within the program.

From which one can draw the following conclusions:

First, the photographic universe is created in the course of a combination game, it is programmed, and it signifies the program. Second, the game proceeds automatically and obeys no intentional strategy. Third, the photographic universe is made up of clear and distinct photographs that each signify one point in the program. Fourth, every single photo is – as the surface of an image – a magical model for the actions of an observer. To summarize: The photographic universe is a means of programming society – with absolute necessity but in each individual case by chance (i.e. automatically) – to act as a magic feedback mechanism for the benefit of a combination game, and of the automatic reprogramming of society into dice, into pieces in the game, into functionaries.

This view of the photographic universe challenges one to look in two directions: towards a society surrounded by the photographic universe and towards the cameras programming the photographic universe. It challenges one to engage, on the one hand, in criticism of the post-industrial society that is coming into being, and, on the other, in criticism of cameras and their programs; in other words: to critically transcend post-industrial society.

To be in the photographic universe means to experience, to know and to evaluate the world as a function of photographs. Every single experience, every single bit of knowledge, every single value can be reduced to individually known and evaluated photographs. And every single action can be analyzed through the individual photos taken as models. This type of existence, then, in which everything experienced, known and evaluated can be reduced to punctuated elements (into 'bits'), is already familiar: It is the world of robots. The photographic universe and all apparatus-based universes robotize the human being and society.

New, robot-like actions are observable everywhere: at bank counters, in offices, in factories, in supermarkets, in sport, dancing. When one looks a bit more closely, the same staccato structure is also perceptible, for example in scientific texts, in poetry, in musical composition, in architecture and in political programs. Correspondingly it is the task of current cultural criticism to analyze this restructuring of experience, knowledge, evaluation and action into a mosaic of clear and distinct elements in every single cultural phenomenon. Within such cultural criticism, the invention of photography will prove to be the point at which all cultural phenomena started to replace the linear structure of sliding with the staccato structure of programmed combinations; not, therefore, to adopt a mechanical structure such as that in the Industrial Revolution, but to adopt a cybernetic structure such as that programmed into apparatuses. Within such cultural criticism, the camera will prove to be the ancestor of all those apparatuses that are in the process of robotizing all aspects of our lives, from one's most public acts to one's innermost thoughts, feelings and desires.

If one now attempts a criticism of apparatuses, one first sees the photographic universe as the product of cameras and distribution apparatuses. Behind these, one recognizes industrial apparatuses, advertising apparatuses, political, economic management apparatuses, etc. Each of these apparatuses is becoming increasingly automated and is being linked up by cybernetics to other apparatuses. The program of each apparatus is fed in via its input by another apparatus, and in its turn feeds other apparatuses via its output. The whole complex of apparatuses is therefore a super-black-box made up of black boxes. And it is a human creation: As a product of the nineteenth and twen-

tieth centuries, human beings are permanently engaged in developing and perfecting it. The time is therefore not far off when one will have to concentrate one's criticism of apparatuses on the human intention that willed and created them.

Such a critical approach is enticing for two reasons. First, it absolves the critics of the necessity of delving into the interior of the black boxes: They can concentrate on their output, human intention. And second, it absolves critics of the necessity of developing new categories of criticism: Human intention can be criticized using traditional criteria. The result of such a criticism of apparatuses would therefore be something like the following:

The intention behind apparatuses is to liberate the human being from work; apparatuses take over human labour – for example, the camera liberates the human being from the necessity of using a paintbrush. Instead of having to work, the human being is able to play. But apparatuses have come under the control of a number of individual human beings (e.g. capitalists), who have reversed this original intention. Now apparatuses serve the interests of these people; consequently what needs to be done is to unmask the interests behind the apparatuses. According to such an analysis, apparatuses are nothing but peculiar machines, the invention of which has nothing revolutionary about it; there is no point therefore in talking of a 'second Industrial Revolution'.

Thus photographs also have to be decoded as an expression of the concealed interests of those in power: the interests of Kodak shareholders, of the proprietors of advertising agencies, those pulling the strings behind the US industrial complex, the interests of the entire US ideological, military and industrial complex. If one exposed

these interests, every single photograph and the whole photographic universe could be considered as having been decoded.

Unfortunately this traditional kind of criticism with its background in the industrial context is not adequate to deal with the phenomenon. It misses the essential thing about apparatuses, i.e. their automaticity. And this is precisely what needs to be criticized. Apparatuses were invented in order to function automatically, in other words independently of future human involvement. This is the intention with which they were created: that the human being would be ruled out. And this intention has been successful without a doubt. While the human being is being more and more sidelined, the programs of apparatuses, these rigid combination games, are increasingly rich in elements: they make combinations more and more quickly and are going beyond the ability of the human being to see what they are up to and to control them. Anyone who is involved with apparatuses is involved with black boxes where one is unable to see what they are up to.

To this extent, one can't talk of an owner of apparatuses either. As apparatuses function automatically and do not obey any human decision, they cannot be owned by anybody. All human decisions are made on the basis of the decisions of apparatuses; they have degenerated into purely 'functional' decisions, i.e. human intention has evaporated. If apparatuses were originally produced and programmed to follow human intention, then today, in the 'second and third generation' of apparatuses, this intention has disappeared over the horizon of functionality. Apparatuses now function as an end in themselves, 'automatically' as it were, with the single aim of maintain-

ing and improving themselves. This rigid, unintentional, functional automaticity is what needs to be made the object of criticism.

The 'humanistic' criticism of apparatuses referred to above is in opposition to this portrayal of apparatuses being transformed into superhuman, anthropomorphic Titans and of thus contributing to the obscuring of the human interests behind apparatuses. But this objection is erroneous. Apparatuses are actually Titans, since they were created with this sole intention. This portrayal attempts to show precisely that they are not superhuman but subhuman – bloodless and simplistic simulations of human thought processes which, precisely because they are so rigid, render human decisions superfluous and non-functional. Whereas the 'humanistic' criticism of apparatuses, by calling upon the last vestiges of human intention behind apparatuses, obscures the danger lying in wait within them, the criticism of apparatuses proposed here sees its task precisely in uncovering the terrible fact of this unintentional, rigid and uncontrollable functionality of apparatuses, in order to get a hold over them.

Returning to the photographic universe: It reflects a combination game, a changing, gaudy jigsaw puzzle of clear and distinct surfaces that each signify an element of the program of the apparatus. It programs the observer to act magically and functionally, and thus automatically, i.e. without obeying any human intention in the process.

A number of human beings are struggling against this automatic programming: photographers who attempt to produce informative images, i.e. photographs that are not part of the program of apparatus; critics who attempt to see what is going on in the automatic game of programming; and in general, all those who are attempting to

create a space for human intention in a world dominated by apparatuses. However, the apparatuses themselves automatically assimilate these attempts at liberation and enrich their programs with them. It is consequently the task of a philosophy of photography to expose this struggle between human being and apparatuses in the field of photography and to reflect on a possible solution to the conflict.

The hypothesis proposed here is that, if such a philosophy should succeed in fulfilling its task, this would be of significance, not only in the field of photography, but for post-industrial society in general. Admittedly, the photographic universe is only one of a whole number of universes, and there are surely much more dangerous ones amongst them. But the next essay will illustrate that the photographic universe can serve as a model for post-industrial society as a whole and that a philosophy of photography can be the starting point for any philosophy engaging with the current and future existence of human beings.

Why a Philosophy of Photography Is Necessary

In the course of the foregoing attempt to sum up the essential quality of photography, a few basic concepts came to light: *image – apparatus – program – information*. These must be the cornerstones of any philosophy of photography, and they make possible the following defini-tion of a photograph: It is an image created and distributed by photographic apparatus according to a program, an image whose ostensible function is to inform. Each one of the basic concepts thus contains within it further con-cepts. *Image* contains within it magic; *apparatus* contains within it automation and play; *program* contains within it chance and necessity; *information* contains within it the symbolic and the improbable. This results in a broader definition of a photograph: It is an image created and distributed automatically by programmed apparatuses in the course of a game necessarily based on chance, an image of a magic state of things whose symbols inform its receivers how to act in an improbable fashion.

This definition has the peculiar advantage for philo-sophy of not being acceptable. One is challenged to prove it wrong since it rules out the human being as a free agent. It provokes one into a contradiction, and contradiction – dialectics – is one of the spurs to philosophy. To this extent, the proposed definition is a welcome starting point for a philosophy of photography.

If one considers the basic concepts *image*, *apparatus*, *program* and *information*, one discovers an internal con-nection between them: They are all based on the 'eternal

recurrence of the same'. Images are surfaces above which the eye circles only to return again and again to the starting point. Apparatuses are playthings that repeat the same movements over and over again. Programs are games that combine the same elements over and over again. Pieces of information are improbable states that break away again and again from the tendency to become probable only to sink back into it again and again. In short: With these four basic concepts, we no longer find ourselves in the historical context of the linear, in which nothing is repeated and everything has a cause yielding consequences. The area in which we find ourselves is no longer ascertainable by means of causal but only by means of functional explanations. Along with Cassirer, we shall have to leave causality behind: 'Rest, rest, dear spirit.' Any philosophy of photography will have to come to terms with the ahistorical, post-historical character of the phenomenon under consideration.

Besides, we have already started to think spontaneously in a post-historical fashion in a whole range of areas. Cosmology is an example of this. We see in the cosmos a system tending towards states that are becoming more and more improbable. It is true that by chance more and more improbable states are coming into being; however – of necessity – these sink back into the tendency to become probable. In other words: We see in the cosmos an apparatus that contains an original piece of information in its output (the 'big bang') and that is programmed to realize and exhaust this information necessarily through chance ('heat death').

The four basic concepts *image*, *apparatus*, *program* and *information*, support our cosmological thinking quite spontaneously, and in so doing, quite spontaneously

prompt us to reach out for functional explanations. The same applies to other areas such as psychology, biology, linguistics, cybernetics and information technology (to mention only a few). We think, quite spontaneously, across the board in an imaginary, functionally programmatic and information-technological fashion. The hypothesis proposed here thus argues that we think like this because we think in photographic categories: because the photographic universe has programmed us to think in a post-historical fashion.

This hypothesis is not as bold as it first seems. It is a hypothesis that has been around for a long time: Human beings create tools and in so doing take themselves as the model for this creation – until the situation is reversed and human beings take their tools as the model of themselves, of the world and of society. Hence the well-known process of alienation from one's own tools. In the eighteenth century, human beings invented machines, and their own bodies served as a model for this invention – until the relationship was reversed and the machines started to serve as models of human beings, of the world and of society. In the eighteenth century, a philosophy of the machine would simultaneously have been a criticism of the whole of anthropology, science, politics and art, i.e. of mechanization. It is no different in our time for a philosophy of photography: It would be a criticism of functionalism in all its anthropological, scientific, political and aesthetic aspects.

The matter is not all that simple, however. For a photograph is not a tool like a machine; it is a plaything like a playing card or chess-piece. If the photograph is becoming a model, then it is no longer a matter of replacing a tool with another tool as a model, but of replacing a type of

model with a completely new type of model. The hypothesis proposed above, according to which we are starting to think in photographic categories, argues that the basic structures of our existence are being transformed. We are not dealing with the classical problem of alienation, but with an existential revolution of which there is no example available to us. To put it bluntly: It is a question of freedom in a new context. This is what any philosophy of photography has to concern itself with.

It goes without saying that this is not a new question: All philosophy has always been concerned with it. But in being so concerned, it was located within the historical context of linearity. In a nutshell, it formulated the question like this: If everything is to have causes and consequences, if everything is 'conditioned', where is there space for human freedom? And all answers, likewise in a nutshell, can be reduced to the following common denominator: The causes are so complex and the consequences so unpredictable that human beings, these limited beings, can act as though they were 'unconditioned'. In the new context, however, the question of freedom is formulated differently: If everything is based on chance and necessarily results in nothing, then where is there space for human freedom? In this absurd climate, the philosophy of photography has to address the question of freedom.

We observe, all around us, apparatuses of every sort in the process of programming our life through rigid automation; human labour is being replaced by automatic machines and most of society is starting to be employed in the 'tertiary sector', i.e. playing with empty symbols; the existential interests of the material world are being replaced by symbolic universes and the values of things

are being replaced by information. Our thoughts, feelings, desires and actions are being robotized; 'life' is coming to mean feeding apparatuses and being fed by them. In short: Everything is becoming absurd. So where is there room for human freedom?

Then we discover people who can perhaps answer this question: photographers – in the sense of the word intended in this study. They are already, in miniature, people of the apparatus future. Their acts are programmed by the camera; they play with symbols; they are active in the 'tertiary sector', interested in information; they create things without value. In spite of this they consider their activity to be anything but absurd and think that they are acting freely. The task of the philosophy of photography is to question photographers about freedom, to probe their practice in the pursuit of freedom.

This was the intention of the foregoing study, and in the course of it a few answers have come to light. First, one can outwit the camera's rigidity. Second, one can smuggle human intentions into its program that are not predicted by it. Third, one can force the camera to create the unpredictable, the improbable, the informative. Fourth, one can show contempt for the camera and its creations and turn one's interest away from the thing in general in order to concentrate on information. In short: Freedom is the strategy of making chance and necessity subordinate to human intention. Freedom is playing against the camera.

However, photographers only provide such answers when called to account by philosophical analysis. When speaking spontaneously they say something different. They claim to be making traditional images – even if by non-traditional means. They claim to be creating works of

art or contributing to knowledge – or being politically committed. If one reads statements by photographers, for instance in the usual works on the history of photography, one is faced with the prevailing opinion that with the invention of photography nothing really far-reaching took place and that everything is basically proceeding just as it did before; only, as it were, that alongside the other histories there is now a history of photography as well. Even though, in practice, photographers have been living for a long time in a post-historical fashion, the post-industrial revolution, as it appears for the first time in the shape of the camera, has escaped their consciousness.

With one exception: so-called experimental photographers – those photographers in the sense of the word intended here. They are conscious that *image*, *apparatus*, *program* and *information* are the basic problems that they have to come to terms with. They are in fact consciously attempting to create unpredictable information, i.e. to release themselves from the camera, and to place within the image something that is not in its program. They know they are playing against the camera. Yet even they are not conscious of the consequence of their practice: They are not aware that they are attempting to address the question of freedom in the context of apparatus in general.

A philosophy of photography is necessary for raising photographic practice to the level of consciousness, and this is again because this practice gives rise to a model of freedom in the post-industrial context in general. A philosophy of photography must reveal the fact that there is no place for human freedom within the area of automated, programmed and programming apparatuses, in order finally to show a way in which it is nevertheless possible to

open up a space for freedom. The task of a philosophy of photography is to reflect upon this possibility of freedom – and thus its significance – in a world dominated by apparatuses; to reflect upon the way in which, despite everything, it is possible for human beings to give significance to their lives in face of the chance necessity of death. Such a philosophy is necessary because it is the only form of revolution left open to us.

Lexicon of Basic Concepts

Apparatus (pl. -*es*): a plaything or game that simulates thought [*trans.* An overarching term for a non-human agency, e.g. the camera, the computer and the 'apparatus' of the State or of the market]; organization or system that enables something to function.

Automatic machine: an apparatus that has to obey an arbitrary program.

Code: a sign system arranged in a regular pattern.

Concept: a constitutive element of a text.

Conceptualization: a specific ability to create texts and to decode them.

Cultural object: an informed object.

Decode: demonstrate the significance of a symbol.

Entropy: the tendency towards more and more probable states.

Functionary: a person who plays with apparatus and acts as a function of apparatus.

Game: an activity that is an end in itself.

History: the linear progression of translation from ideas into concepts.

Idea: a constitutive element of an image.

Idolatry: the inability to read off ideas from the elements of the image, despite the ability to read these elements themselves; hence: worship of images.

Image: a significant surface on which the elements of the image act in a magic fashion towards one another.

Imagination: the specific ability to produce and to decode images.

Industrial society: a society in which the majority of people work at machines.

Inform: 1. create improbable combinations of elements; 2. imprint them upon objects.

Information: an improbable combination of elements.

Machine: a tool that simulates an organ of the body on the basis of scientific theories.

Magic: a form of existence corresponding to the eternal recurrence of the same.

Memory: information store.

Object: a thing standing in our way.

Photograph: a flyer-like image created and distributed by apparatus.

Photographer: a person who attempts to place, within the image, information that is not predicted within the program of the camera.

Plaything: an object in the service of a game.

Post-history: the translation of concepts back into ideas.

Post-industrial society: a society in which the majority of people are occupied in the tertiary sector.

Primary and secondary sector: the areas of activity in which objects are produced and informed.

Production: the transfer of a thing from nature into culture.

Program: a combination game with clear and distinct elements [*trans.* A term whose associations include computer programs, hence the US spelling].

Reality: what we run up against on our journey towards death; hence: what we are interested in.

Redundancy: repetition of information; hence: the probable.

Rites: actions corresponding to the magic form of existence.

Sign: a phenomenon that signifies another.

Significance: the aim of signs.

State of things: a scenario in which what is significant are the relationships between things and not things themselves.

Symbol: a sign consciously or unconsciously agreed upon.

Symptom: a sign brought about by its significance.

Technical image: a technological or mechanical image created by apparatus.

Tertiary sector: the area of activity in which information is created.

Text: series of written signs.

Textolatry: the inability to read off concepts from the written signs of a text, despite the ability to read these written signs; hence: worship of the text.

Tool: a simulation of an organ of the body in the service of work.

Translation: switching over from one code to another; hence: jumping from one universe into another.

Universe: 1. the totality of combinations of a code; 2. the totality of significations of a code.

Valuable: something that is as it is supposed to be [*trans.* able to be filled with value].

Work: the activity that produces and informs objects.

Afterword

This, I think, shows what being free means. Not cutting off one's ties with others but making networks out of these connections in co-operation with them. Émigrés become free, not when they deny their lost homeland, but when they come to terms with it. VILÉM FLUSSER

A philosophy of photography is necessary because it is the only form of revolution left open to us. Vilém Flusser's book, first published in German in 1983, constructs the first steps towards a philosophy of photography, or rather towards the question of whether or not all philosophy nowadays must be dedicated to thinking in terms of a photographic universe – in other words, committed to the paradox of philosophizing about the end of Becoming at the Coming of the end. The range of Flusser's major work, from his *Geschichte des Teufels* (History of the Devil), published in Brazilian Portuguese in São Paulo in 1965, right through to his numerous posthumous fragments, displays a phenomenological commitment. Flusser's writing is 'nomadological'; it reflects the fate of being an émigré in the twentieth century, the 'rootlessness', the 'groundlessness' and the basic insecurity of human destiny. Thus, to understand his writing and, above all, the motivations of his writing, it should be remembered that Flusser grew up as a child of Jewish intellectuals in Prague, that he began studying philosophy in 1939 at the age of nineteen, that in 1940 he emigrated to London with Edith Barth (whom he married in 1941) and that up to his death in a road

accident in 1991 he led a life of 'groundlessness' (this is the title of his philosophical autobiography), of 'homelessness' in Brazil, then in Italy and finally in France. His mother and sister were murdered at Auschwitz, his father beaten to death at Buchenwald.

In London in 1940, as he says in one essay, 'in this – by continental standards – somewhat inscrutable England', 'freed' from Prague by having been forced to leave, nonetheless aware of 'the coming dislocation of humanity', he formulated the basic question of his writing:

> Changing the question 'free from what?' into 'free for what?'; this change that occurs when freedom has been achieved has accompanied me on my migrations like a basso continuo. This is what we are like, those of us who are nomads, who come out of the collapse of a settled way of life.*

In the same way that, in the process of photography, things lose their place, are 'displaced' and go on a journey made up of countless experiences, and that telematic images capture and encircle displaced people, Flusser's thought should be seen as a process of wandering that does not come either to a 'clearing' (in Heidegger's sense) or to any transcendental place. The forward movement of this way of thinking consists much more of the deliberate repetition of every step that nevertheless fails ultimately to indicate the way out. Perhaps it is thanks to this migration, as experienced and reflected upon, that Flusser, in his best essayist manner, is able to show us everyday things with precisely the urgency and sharp analytic focus that characterizes the great philosophers and theorists of the twentieth century (Nietzsche, Husserl, Heidegger, Wittgenstein and Kafka).

Flusser's thinking proceeds by means of etymological statements, perceiving language very much as the 'home of being' – as movement, as media communication – whose capacity to integrate experience is being altered increasingly by technological media. Since he always wrote in a number of languages and translated them back and forth – Portuguese, English, French, German and Czech – the idea of translation is at the heart of all of his works, of his way of thinking. However, translation means not so much the formal linguistic act of translation as the human act of leaving and then rediscovering an area of language. Thus, in this continual state of being on the move like nomads, languages acquired for Flusser the original character born out of elemental difference or separation and out of the desire to be on the move, to build bridges, to communicate. The demand for translation originates from all those migrations that did not arise out of persecution and the need to seek refuge elsewhere; at the same time, Flusser's writing demands that one learns the lesson of translation by looking at catastrophes and human degradation caused by political persecution. Every translation signifies the space-between, the gap, the historical chasm or the repression of history; translation is the most cautious form of communication since there is always the inherent admission of a certain departure and an uncertain arrival. In this sense, Flusser's philosophical writing must be seen as a departure – attempting to grasp the transition from a world view characterized by humanism to a world of the 'techno-imaginary' springing from nowhere – and viewing the artificial paradises of 'digital fog' as the end of the grand projects of the philosophy of history.

Flusser has been called the philosopher of new media; his name is often mentioned in the same breath as Jean

Baudrillard and Paul Virilio. Flusser's thought is neverthe-
less far removed from the eschatalogical dimension of
Virilio's theory of the media and from the 'criminological'
dimension of Baudrillard's theory of simulations. Flusser
pinned his hopes on the potentiality of the Now that is
based neither on human vigilance nor on social progress –
of the late Marxist or the late capitalist variety – but on a
nameless, post-historical universe of technical images.
Flusser is no apologist for new media, yet it is with deep
melancholy that he sees in the disappearance of historical
references a devastation of the territory of history and an
ushering in of a dislocated world view. In this respect, his
philosophy of photography is very much a philosophy of
translation continually moving towards the philosophy of
emigration that was the aim of his writing:

> The universe of technical images emerging all
> around us, represents the fulfilment of the ages, in
> which action and agony go endlessly round in cir-
> cles. Only from this apocalyptic perspective, it seems,
> does the problem of photography assume the impor-
> tance that it deserves.

This book can be seen as a work of philosophy in which
photography is elevated to an allegory of post-industrial
and post-historical thought. Thus one should not be sur-
prised that there are no descriptions of photographic
images nor are there any photographs included by way of
illustration. Flusser is not concerned here with the history
of photography, but rather with presenting a way of
thinking about history *post*-photography. Neither is he
concerned with describing current 'redundant' or 'inform-
ative' photographs, nor with the art of photography or
even photography as art. *Towards a Philosophy of*

Photography is a work of doubt and concern, a work of indecision characteristic of the photographic universe in which one still has to come to terms with a history steeped in photographs and the 'collective memory going endlessly round in circles'. It argues for a way of thinking about concepts in which criticism of the primary medium of technical images has to be broadened into general cultural criticism. The philosophy of photography is 'a criticism of functionalism in all its anthropological, scientific, political and aesthetic aspects'; the act of photography, according to Flusser, is one of 'phenomenological doubt'.

This book is of prime interest to anyone studying the effects of the information society on the basic structures of human existence. The original edition was followed by *Ins Universum der technischen Bilder* (Entering the Universe of Technical Images), a book which was published two years later, and the essay *Die Schrift* (Writing), published in 1987. These should become set texts for readers today who feel the lack of a Buckminster Fuller, Harold Innis or Marshall McLuhan, who feel they can no longer fall back on Kant's *Critique of Judgement* and who do not feel fully stretched by Neil Postman. Flusser's arguments can be taken as a plea for a radically different kind of education in which the domination of technical images must be counter-balanced by a critical program of education on image-programming. Education is challenged, both to continue the struggle against illiteracy and also to uphold the warning – proclaimed in the 1920s by Moholy-Nagy – that those who are ignorant in matters of photography will be the illiterates of tomorrow.

The first essay in this book explores the replacement of the culture of linear writing by the culture of technical images due to the invention of photography in the first

third of the nineteenth century. Flusser considers the invention of photography to be as earth-shattering an event for the history of humankind as the invention of writing in the second century BC. If the relationship of the subject to the text (textolatry) and to the image (idolatry) was determined by magic and ritual, in the universe of photography this relationship is characterized by the functionalism of the apparatus and the operator. Whereas transcendence once occupied the field of meaning in the form of myth, and gods – like authors – stood at the centre of the hermeneutic circle, the interpretation of the technical image becomes an act of grasping the transdescendent – functional and circular interactions between the four essential and non-causal determinants of the photographic universe: *image*, *apparatus*, *program* and *information*. The gods have, as it were, been turned into 'functionaries' who put their efforts into the processes of communication – i.e. 'manipulated information' – that they think they have under their control, but whose 'computative' logic they are nevertheless subject to. Photographers are functionaries, they make use of apparatuses using programs linked to them and produce information. The industrial evolution of apparatuses and programs has to be ordered in such a way that photographers' abilities are exceeded and yet program capabilities are not exhausted. To a certain extent, the 'black box' as the hermeneutic residue of magic must still be able to offer its functionary a guarantee of meaning. This is the measure of individuality and the degree of information provided by the photographic image; in the end, Flusser identifies these two things only as experimental photography, i.e. the literal deconstruction of the whole apparatus and the overall program of photography.

Photography initiated the transition from the industrial and historical to the post-industrial and post-historical age. This was determined, according to Flusser, by the shift or 'redirection' of power 'from the material to the symbolic' and replaced matter and work with the twin pillars of information and play – 'Instead of having to work, the human being is able to play.' The *apparatus*, the *black box*, the *hardware* represent a form of 'robotization' and automation of cultural production (not therefore to be confused with the debate about *apparatus* in film theory since the 1960s); as a work-thing (*Werkzeug*) it is a play-thing (*Spielzeug*) that simulates a way of thinking and creates images according to the combinations offered by the program (the *software*). Flusser was no Luddite; he did, however, press for a criticism of apparatuses whose production serves the interests of social power and whose aim was that 'the human being would be ruled out'. He differentiated his criticism of apparatuses from humanistic criticism which continued to invoke human responsibility and denied the fait accompli that the human being had been excluded from the world of apparatuses. The paradox he formulates about the 'photographic criticism' that is needed is, to use his words, 'uncovering the terrible fact of this unintentional, rigid and uncontrollable functionality of apparatuses in order to get a hold over them'. In this way, photographers as critical functionaries are charged with the responsibility of informing by means of images, of imposing information onto a surface. Whether photography is being employed in the service of art, science or politics, photographers have a duty to analyze their own intentions. The aim of any single photograph is – as Adorno says – the disclosure of the 'logic of being produced'. Thinking about photography means defining

the playful combinations contained within the apparatus and seeing the program as a concept of freedom. The only names mentioned by Flusser, initially just in passing – Kafka and Kant – determine the ethical motivation of this social philosophy. 'Freedom is playing against the camera,' even though the human beings taking the photographs cannot escape the state of dependence that they have brought upon themselves, their positive 'theatre of the absurd'. Their job must be to use images to create spaces running counter to those that are programmed within apparatuses.

In the information society, questions of property and social emancipation common to both capitalism and socialism have evolved into problems of the 'programming and distribution of information'. The solution to these problems in the 'post-historical' and 'post-ideological' age is no longer aimed at a social situation that can be achieved historically. Any such teleological model has now been transformed into the circular model of self-reflexive, autopoietic apparatus. 'As long as the photograph is not yet electromagnetic, it remains the first of all post-industrial objects,' Flusser wrote in 1983. 'Even though the last vestiges of materiality are attached to photographs, their value does not lie in the thing but in the information on their surface.' The act of photography, in which information is encoded and subsequently decoded by the receiver, signifies an awareness of how things are devalued by their photographic representation. The moment of loss in creating a photographic image – interpreted by philosophers from Walter Benjamin to Roland Barthes as being a precondition for 'phenomenological doubt' – must not lead to the fetishizing compensation of lost objects by their symbolic replacement; it must instead educate us

into an awareness of this translation within the image. Admittedly, Flusser does not present any program for this, makes no reference either to directions in style and art or to ideal photographers; instead, by pointing in the direction of experimental photography, he indicates that this 'informative' photography has to be distinguished from 'redundant' photography which exhausts itself stylistically and venerates apparatuses and programs. Experimental photography must expose these cracks in representation, the absurdity of any 'post-historical' technical representation.

Flusser's work on the philosophy of photography should be read as a treatise on the crisis of history that can no longer be resolved. The reader will be unable to avoid being confronted over and over again with the melancholy reason behind the observations presented here. When texts were no longer able to form narratives, 'technical images were invented'. Their job was 'to make texts comprehensible again, to put them under a magic spell – to overcome the crisis of history'. There is a connection between the invention of photography and Gustave Flaubert, whose dearest wish is said to have been to write a book about Nothing. After reading Flusser, one sees that the end of the story turns out to be the basic information of any 'informative' photography. The obscuring of the aesthetic component of the program of the twentieth century formed the dark apocalyptic background to the indescribable catastrophe of human history against which Flusser formulated his philosophy of freedom.

* Vilém Flusser, 'Wohnung beziehen in der Heimatlosigkeit' (Finding a Home in Homelessness), in *Von der Freiheit des Migranten: Einsprüche gegen den Nationalismus* (On the Freedom of the Migrant: Objections to Nationalism) (Mannheim, 1994), p. 17.